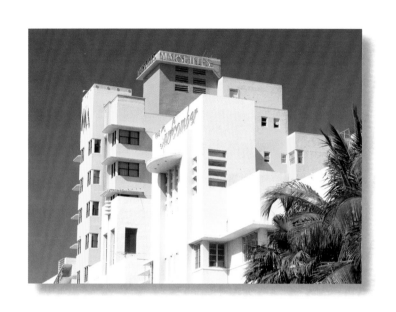

MIAMI

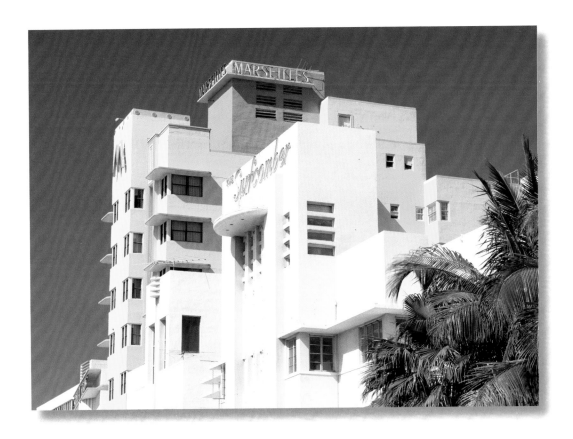

whitecap

Text by Helen Stortini
Edited by Mike Chilton
Photo editing by Helen Stortini
Proofread by Viola Funk
Cover and interior design by Steve Penner
Typeset by Helen Stortini, Marjolein Visser, and Diane Yee

Printed and bound in Canada by Friesens

Library and Archives Canada Cataloguing in Publication

Stortini, Helen
 Miami / Helen Stortini, 1976–
 (America series)
 ISBN 1-55285-724-7
1. Miami (Fla.)—Pictorial works. I. Title. II. Series.
F319.M6S76 2005 975.9'381064'0222 C2005-903561-7

The publisher acknowledges the support of the Canada Council and the Cultural Services
Branch of the Government of British Columbia in making this publication possible.
We acknowledge the financial support of the Government of Canada through the Book
Publishing Industry Development Program for our publishing activities.

*For more information on the America Series and other titles by Whitecap Books,
please visit our website at www.whitecap.ca.*

Golden sand beaches, a thriving arts scene, a fabulous nightlife, and a booming financial district have always drawn people to Miami. Visitors and residents alike revel in the diversity of this cosmopolitan center—from the vibrant street festivals of Little Havana to the architectural marvels of South Beach's trendy Ocean Drive and from the serene, tree-lined boulevards of Coral Gables to Brickell Avenue's sleek mirrored skyscrapers.

Miami first made its mark as an international destination in the 1920s and 1930s. America's wealthy elite—such as Harvey Firestone and William Randolph Hearst—were drawn to Miami Beach's unspoiled beauty and built mansions on what is now known as Millionaire's Row. Vacationers followed in droves to soak up the ever-shining sun and play in the crystal-clear waters of the Atlantic. The now world-famous art deco hotels sprung up on South Beach to accommodate this influx of tourists.

After the Cuban revolution the city expanded when over half a million Cuban immigrants relocated to the Miami area, infusing it with Hispanic culture and tradition. Today, more than 60 percent of Miami's population is of Hispanic descent. Often called the "Gateway to the Americas," this multicultural center conducts over half of the nation's trade with Central America and is home to many international corporations.

Rich in culture, this eclectic metropolis creates a perfect balance between the hustle and bustle of a modern city and the tranquility of a coastal beach town. Celebrities and tourists alike continue to flock to the countless attractions of this exciting urban center, now considered one of the hippest and most fashionable locations in the nation.

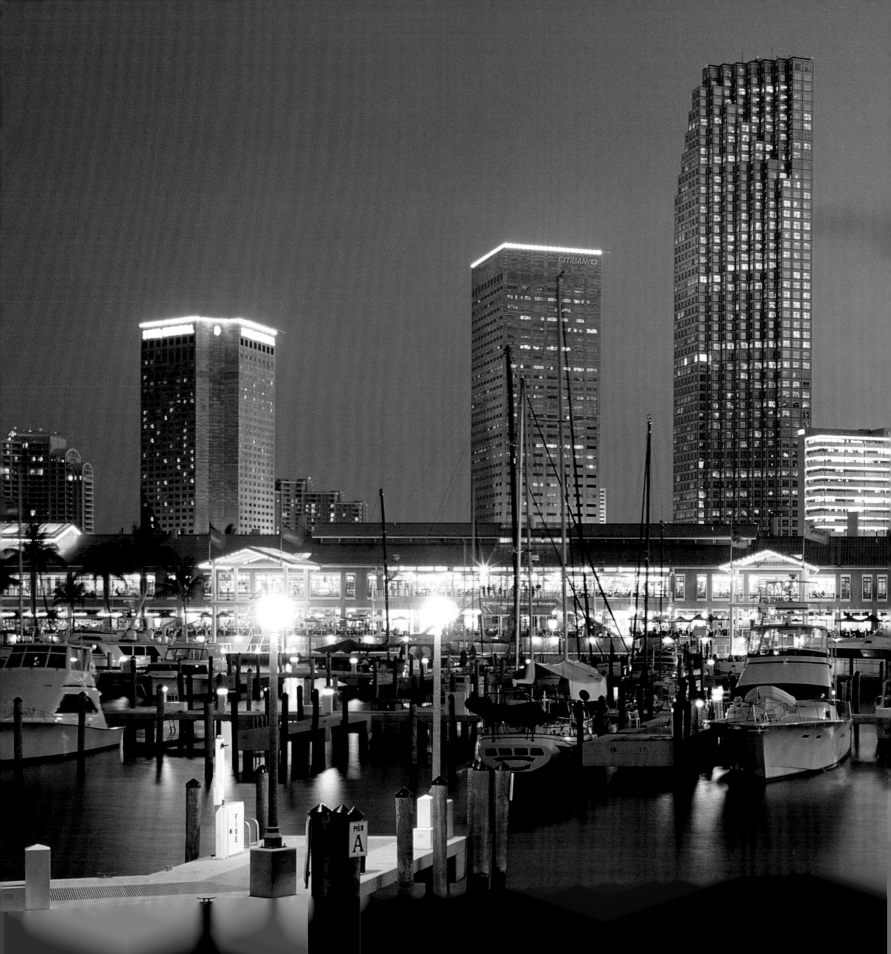

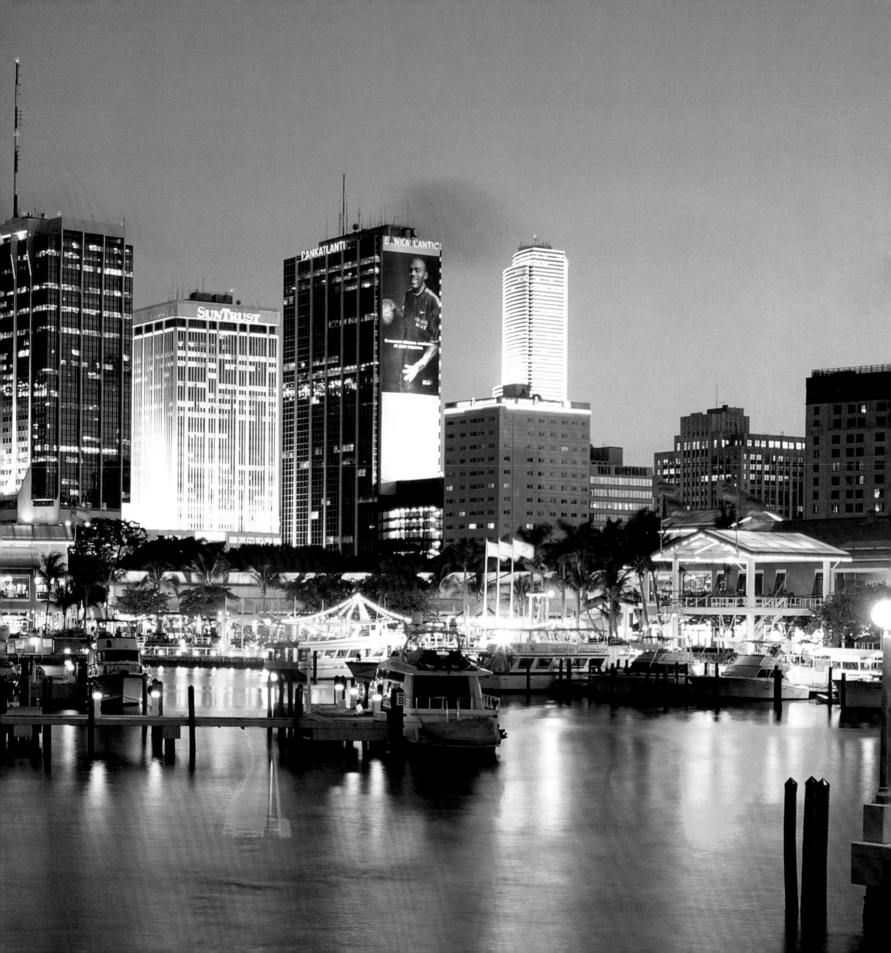

Miami's downtown core contains more than 13 million square feet of office space and 5 million square feet of retail space. The Bank of America Building— a 37-story office tower—offers restaurants, lush landscaping, and outstanding views of the city.

PREVIOUS PAGE
Overlooking Biscayne Bay, Miami's sleek and modern downtown is a hub of finance, culture, trade, and tourism. More than 360,000 people call this international city their home.

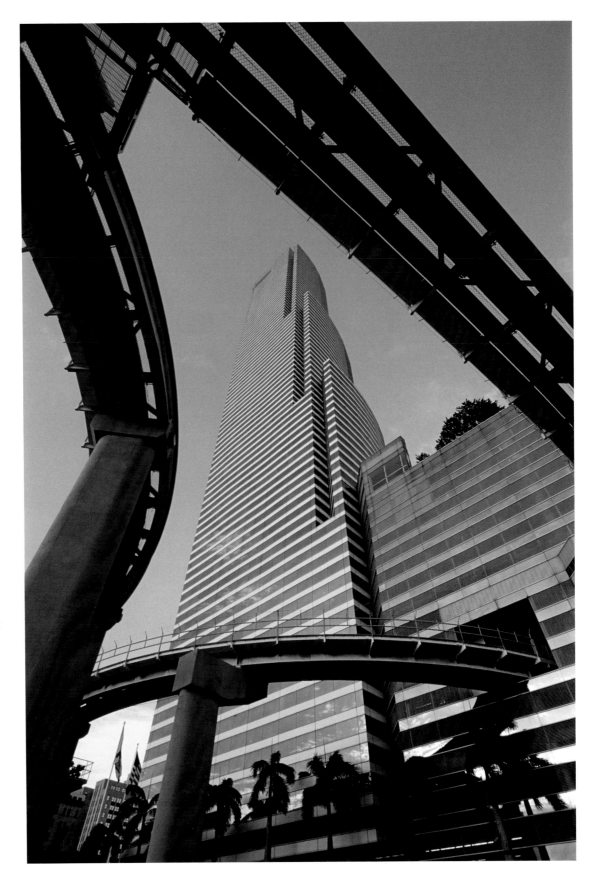

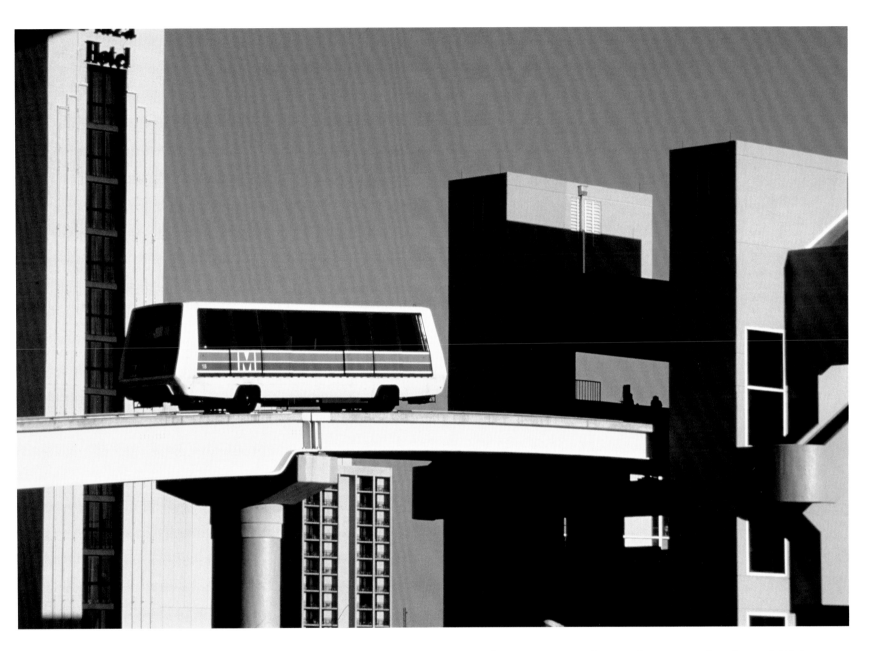

The Metromover—a free automated people-mover built in 1986—
services downtown Miami. There are 21 conveniently located stations
throughout the city center.

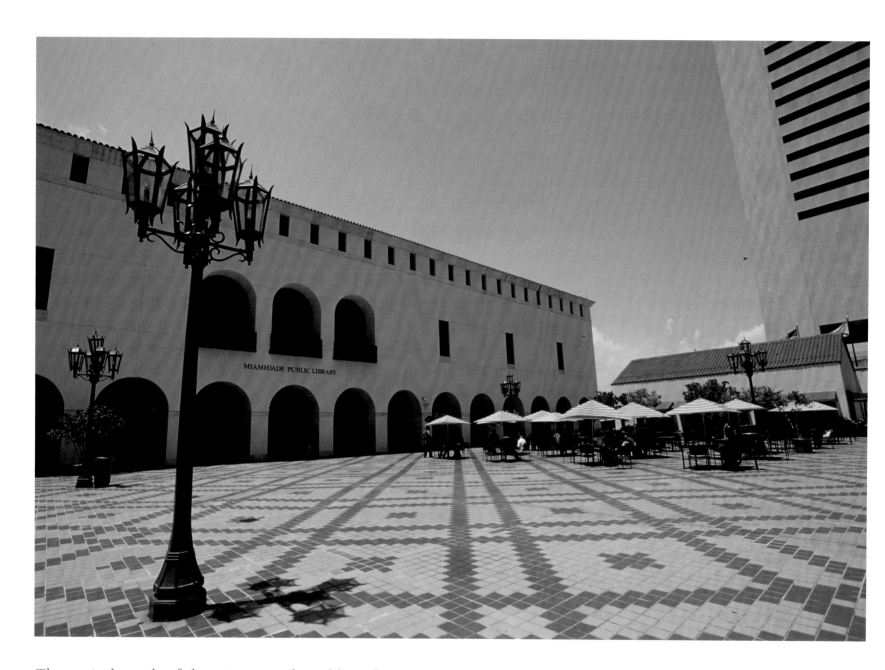

The main branch of the Miami-Dade Public Library, the Historical Museum of Southern Florida, and the Miami Art Museum are all located at the Miami-Dade Cultural Center. These buildings surround an open-air plaza, where people gather to enjoy the sunshine.

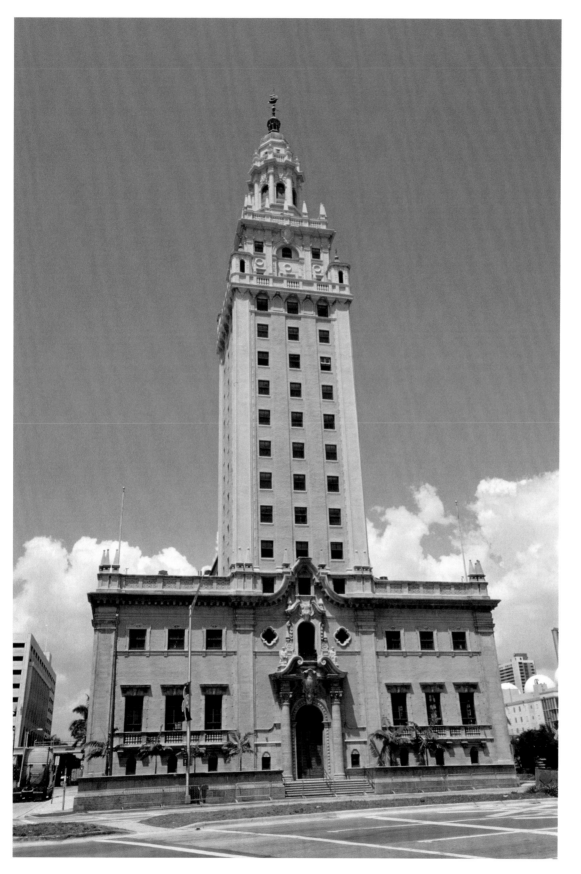

Originally built in 1925 for the *Miami Daily News*, the Freedom Tower was used as a reception center for Cuban refugees from 1962 to 1974. This stately building overlooking Biscayne Bay is now the Cuban-American Museum.

Home to the National Basketball Association's Miami Heat, the American Airlines Arena can seat up to 20,000 fans. Gloria Stephan's millennium concert marked the arena's opening on December 31, 1999.

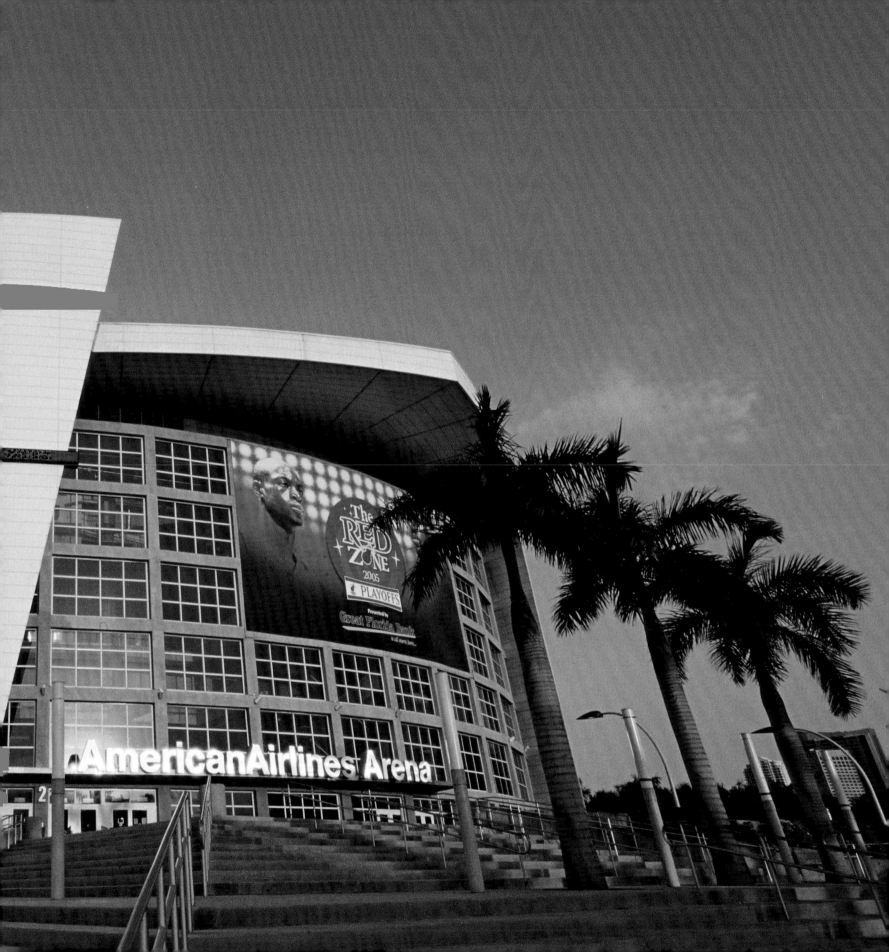

Once the site of Miami's first trading post set up by William and Mary Brickell in the 1870s, Brickell Avenue has morphed into a booming commercial center. Nicknamed the "Wall Street of the South," this wide, tree-lined street is home to more than 100 financial institutions and is the nation's second-largest international banking district.

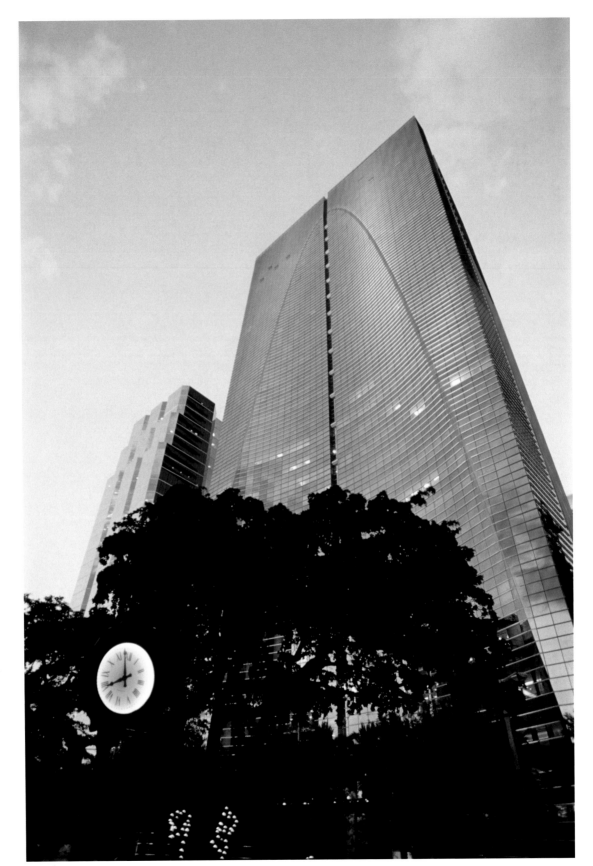

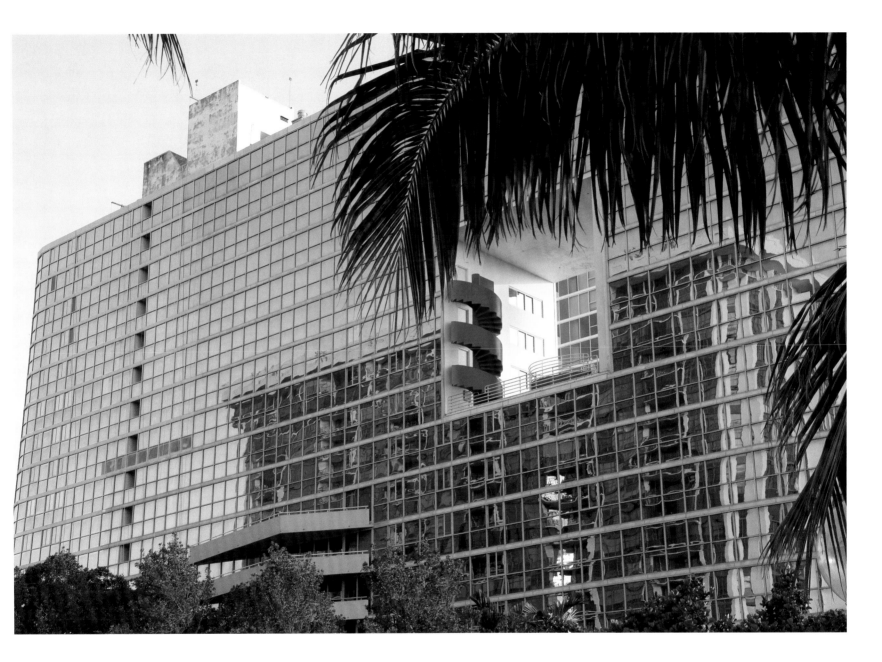

Designed by renowned architectural group Arquitectonica, The Atlantis is one of Brickell Avenue's most famous buildings. This apartment complex's art deco colors and hollowed-out center were seen in the title montage of the 1980s hit show "Miami Vice."

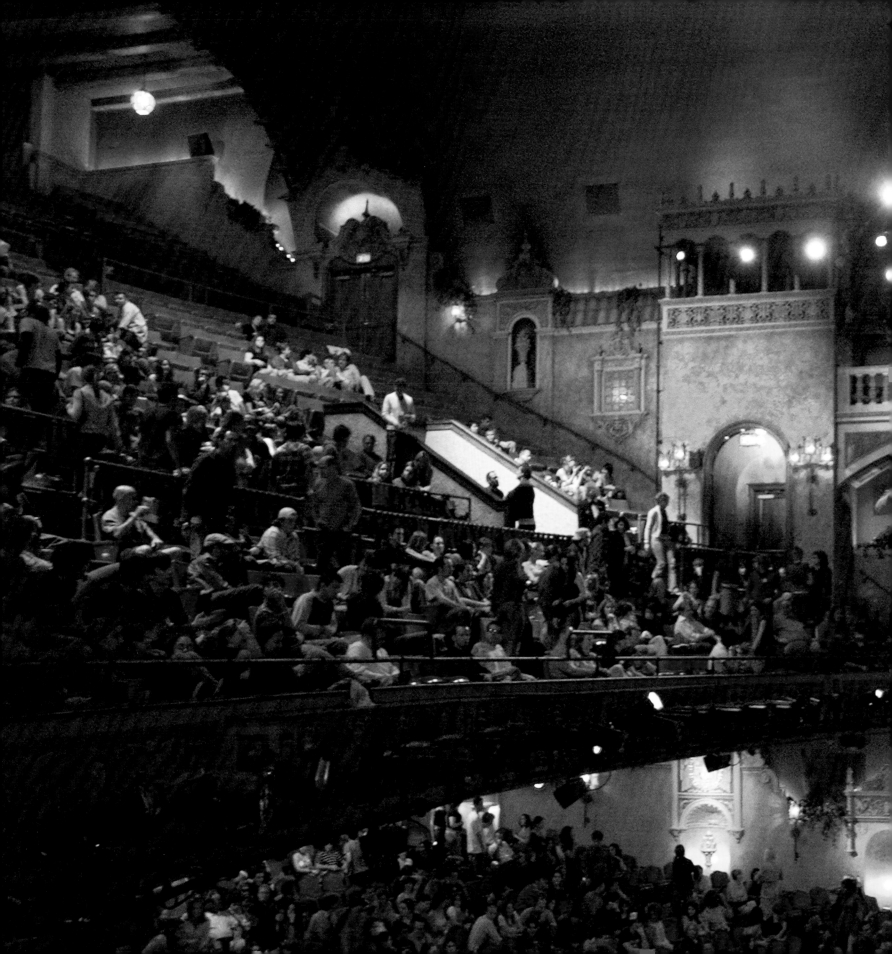

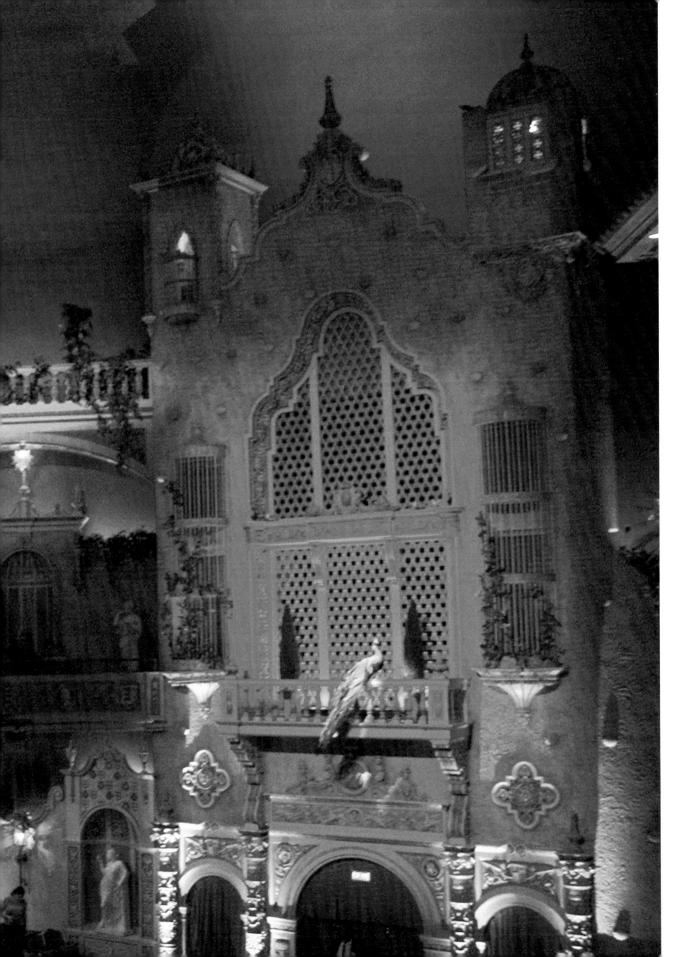

This magnificent venue originally opened as the Olympia Theater. In 1975, philanthropist Maurice Gusman saved the grandiose building from destruction, bestowing it to the city as the Gusman Center for the Performing Arts.

17

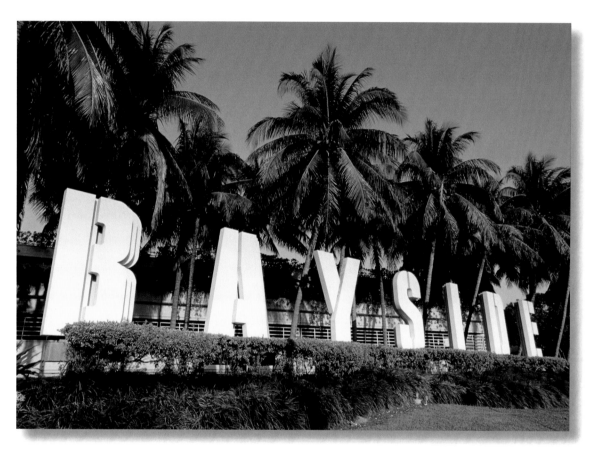

Bayside offers an exotic array of Cuban food, local art, regional music, world-class shopping, and picturesque waterfront surroundings.

Bordered by the ocean, and surrounded by rivers and lakes, Miami is a marine enthusiast's playground. The Miamarina marina at Bayside can accommodate yachts and boats of varying sizes in its 130 slips.

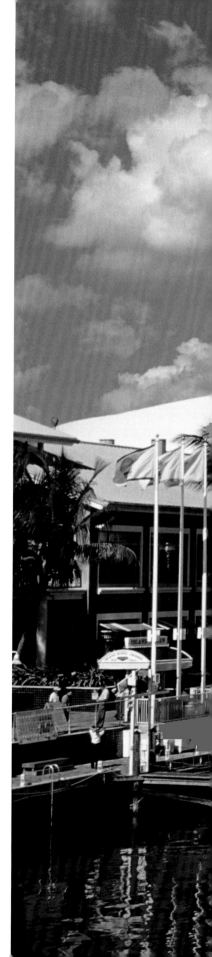

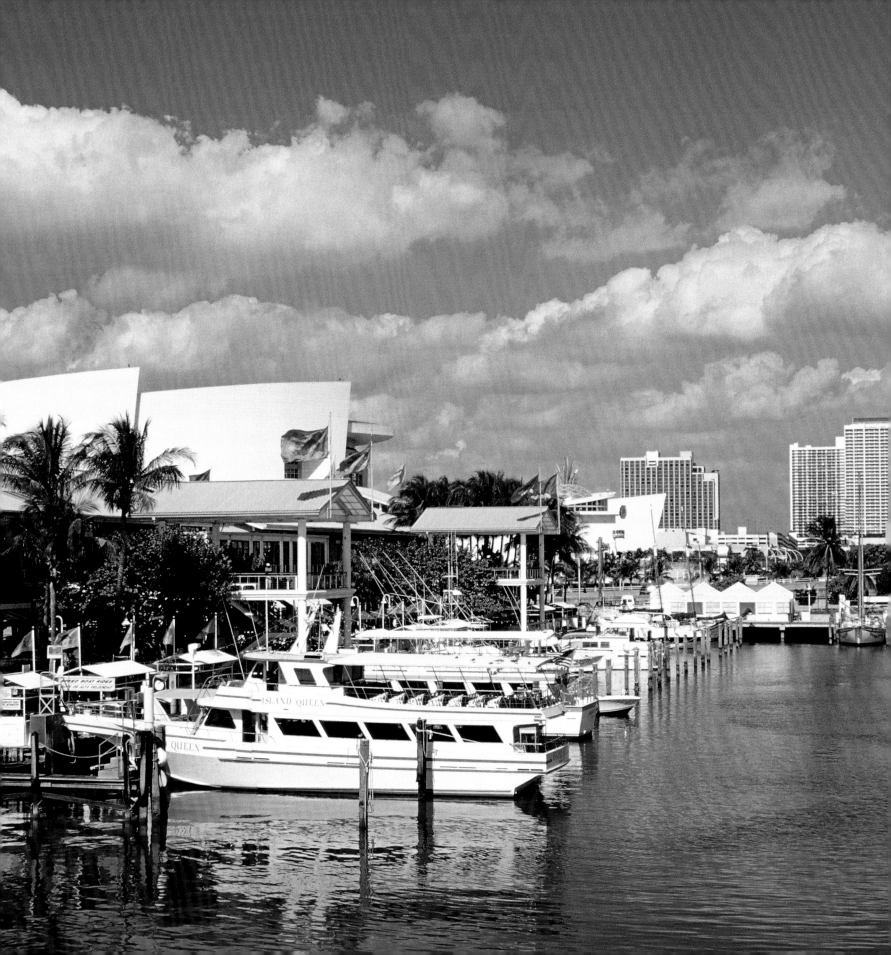

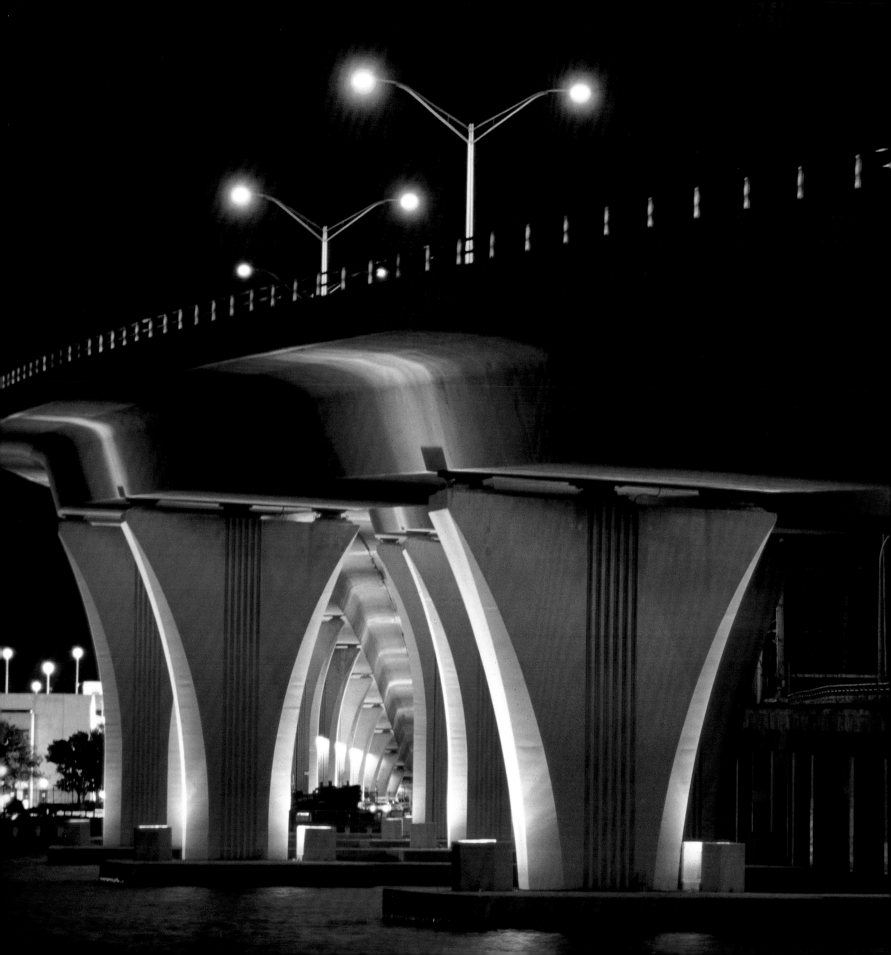

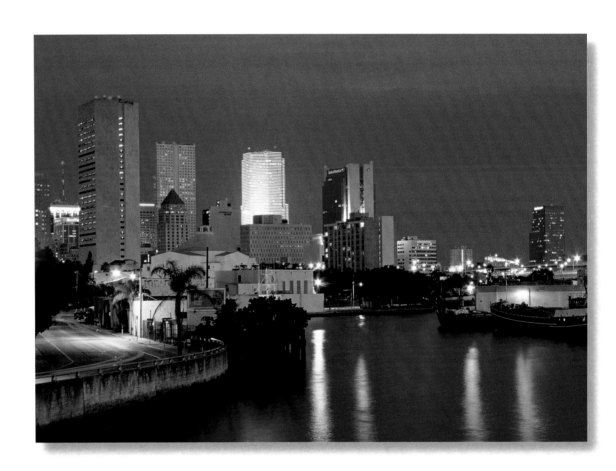

The Miami River runs 5.5 miles from Biscayne Bay through the heart of the city to the Miami International Airport. The river's 32 private terminals clear more than $4 billion in cargo a year, making it Florida's fifth-largest seaport.

Accessed by Port Boulevard, the Dante B. Fascell Port of Miami-Dade generates more than 90,000 jobs in the Miami-Dade County area and has an annual economic impact of $12 billion.

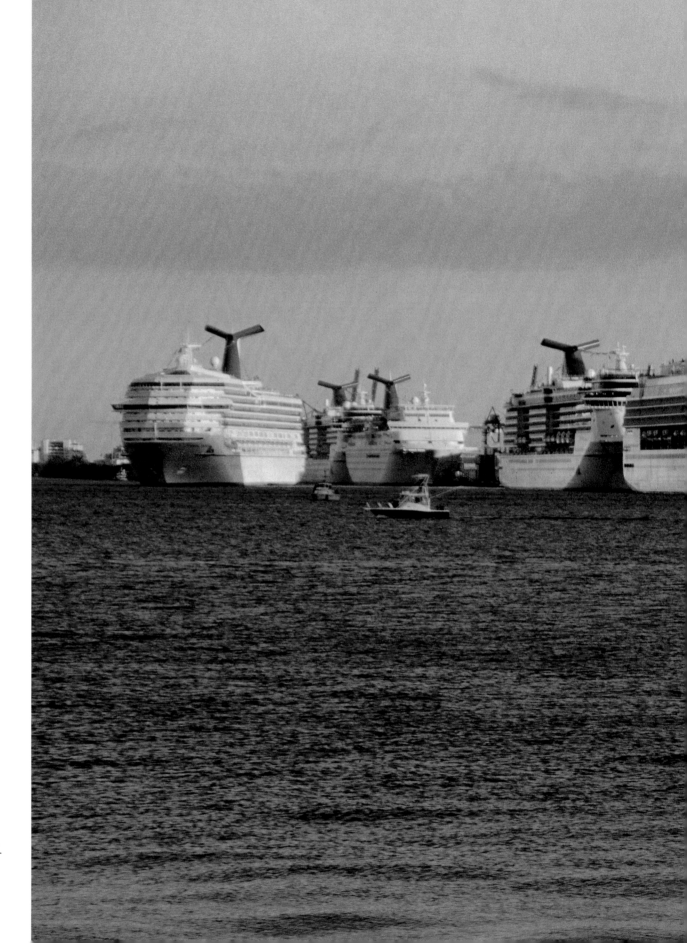

The Port of Miami-Dade is the cruise capital of the world. It is homeport to more than 15 cruise ships and serves nearly 4 million passengers each year.

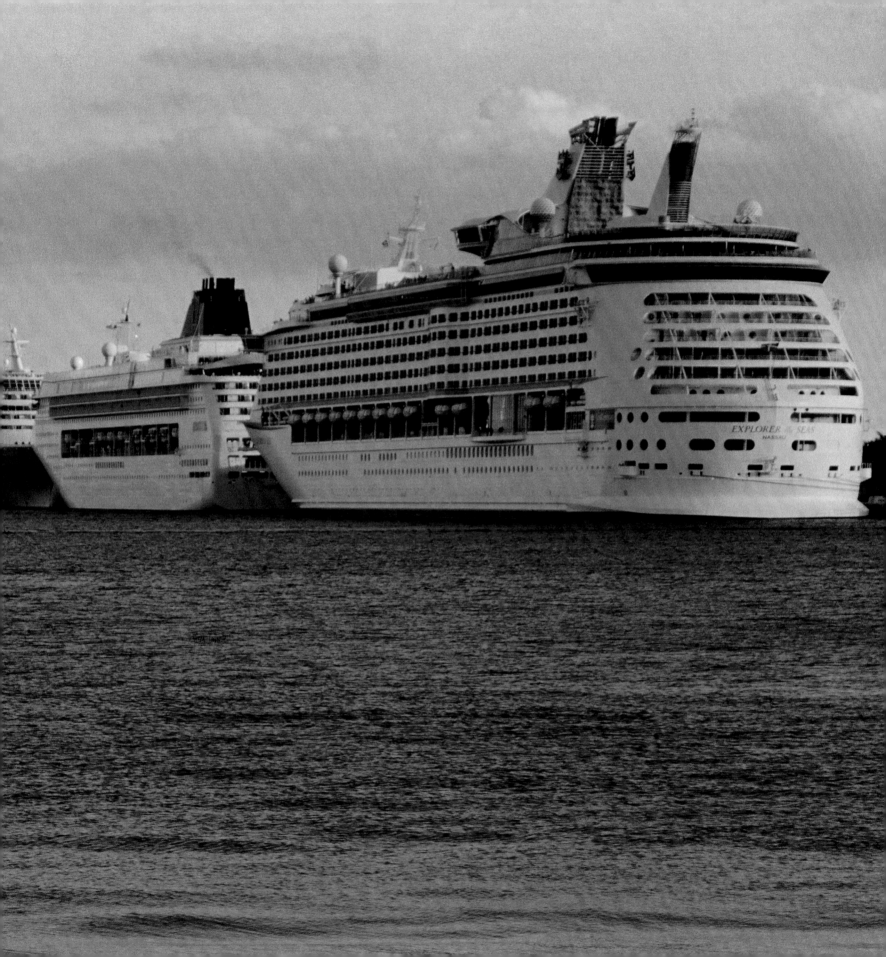

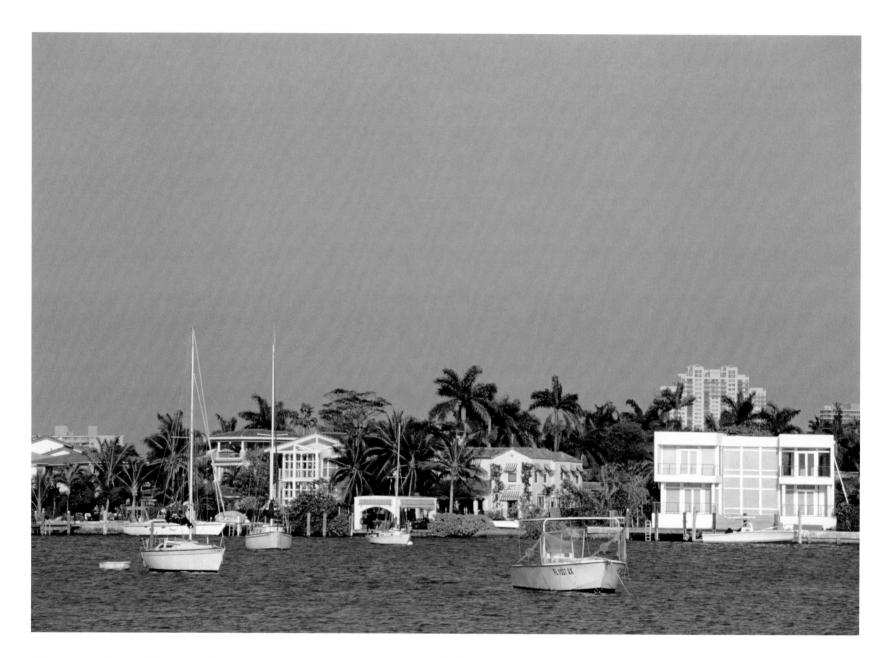

The islands in Biscayne Bay have been home to many celebrities.
Legendary gangster Al Capone lived in a Spanish-style estate on
Palm Island—in between prison stints—until his death in 1947.

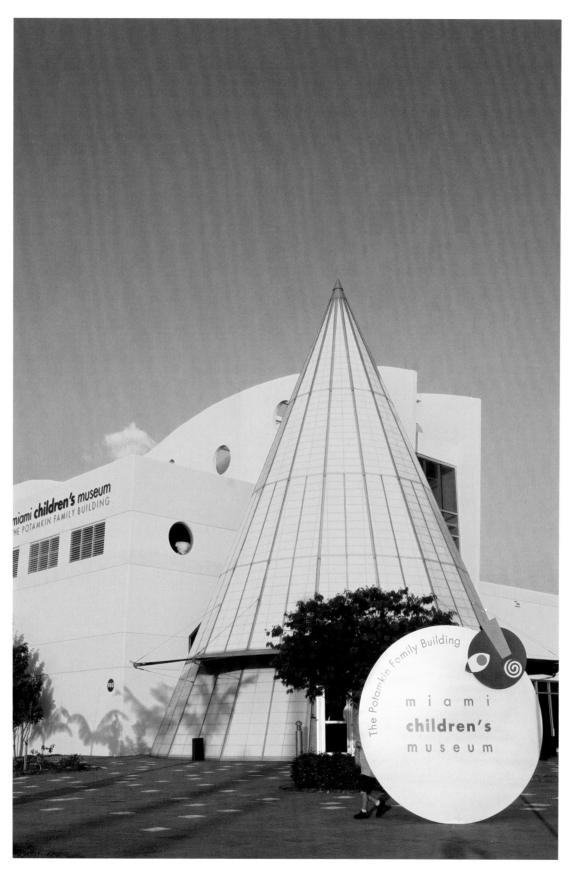

The Children's Museum, on Watson Island, offers hundreds of interactive exhibits related to arts, culture, and community. Visitors of all ages are encouraged to explore the 56,500-square-foot facility.

OVERLEAF
In 1913, John Collins and Carl Fisher built a two-and-a-half-mile wooden bridge across Biscayne Bay. The bridge opened up access to the 7.1 square miles of land known today as Miami Beach. Almost 90,000 people now call this small barrier island home.

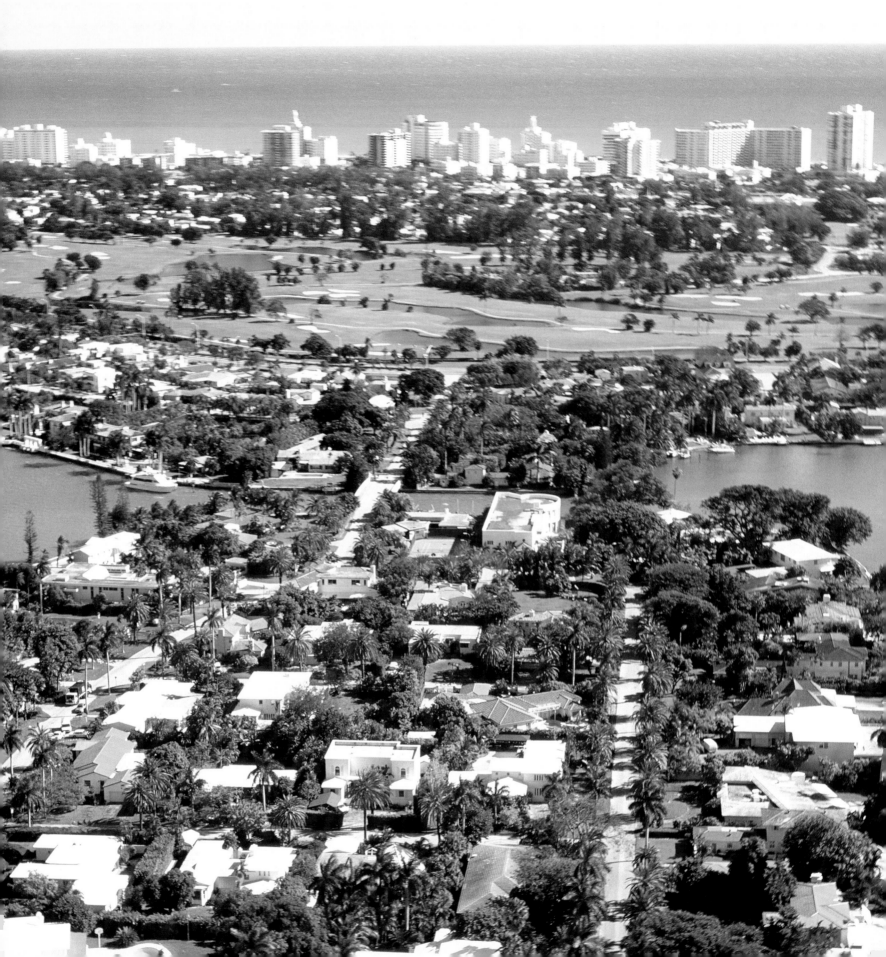

Bal Harbour is a favored getaway for the rich and famous. This upscale village is home to the luxurious Bal Harbour Shops, an elegant shopping complex that achieves more sales per square foot than any other shopping outlet in the nation.

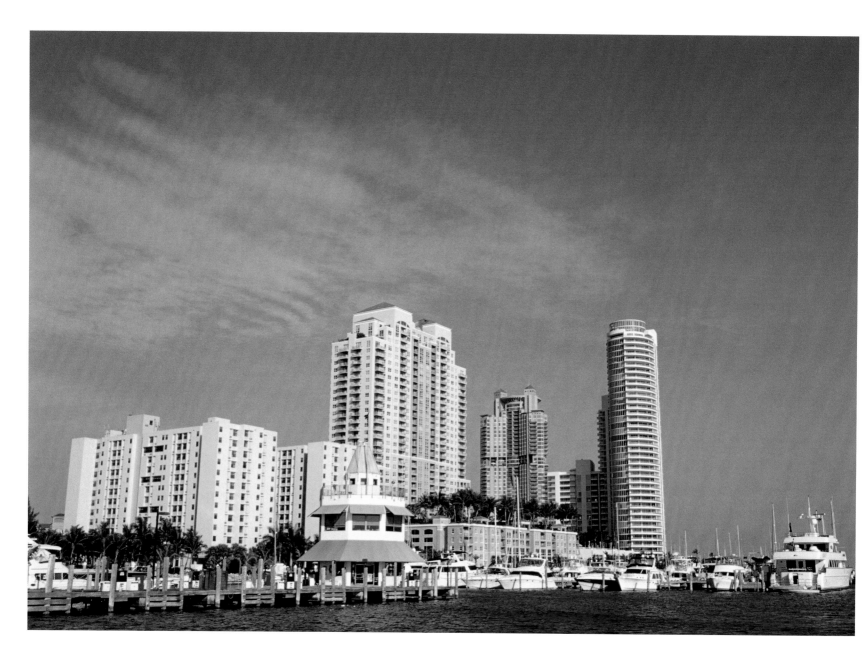

Miami Beach has the second-highest housing density in the nation—behind only New York City. Its waterfront is filled with high-rise condominiums and million-dollar mansions.

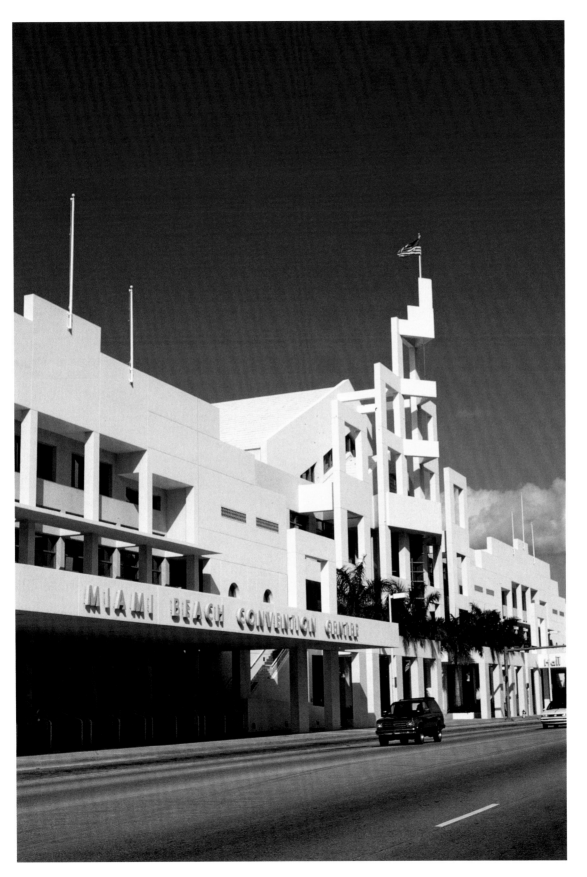

Designed in Miami Beach's signature art deco style, the Miami Beach Convention Center spans four city blocks.

OVERLEAF
Palm-lined, white sand beaches and bright blue ocean waters make Miami Beach look like paradise. This postcard-inspiring setting is the holiday destination of choice for visitors from around the world.

29

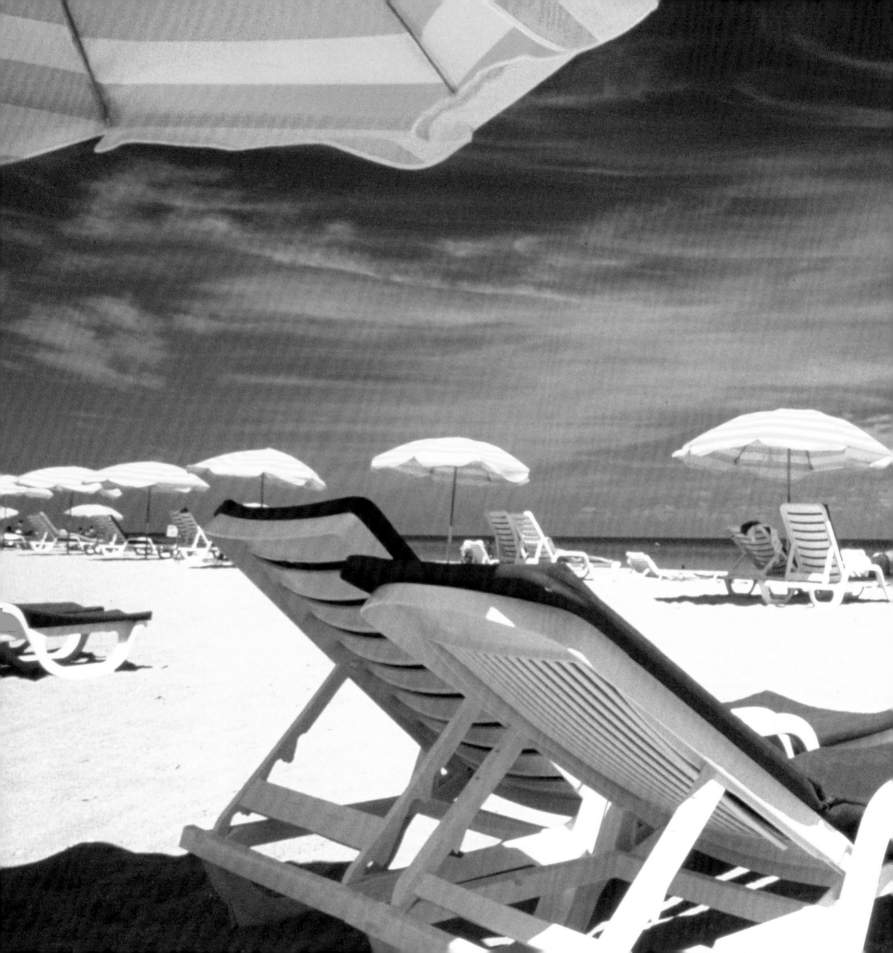

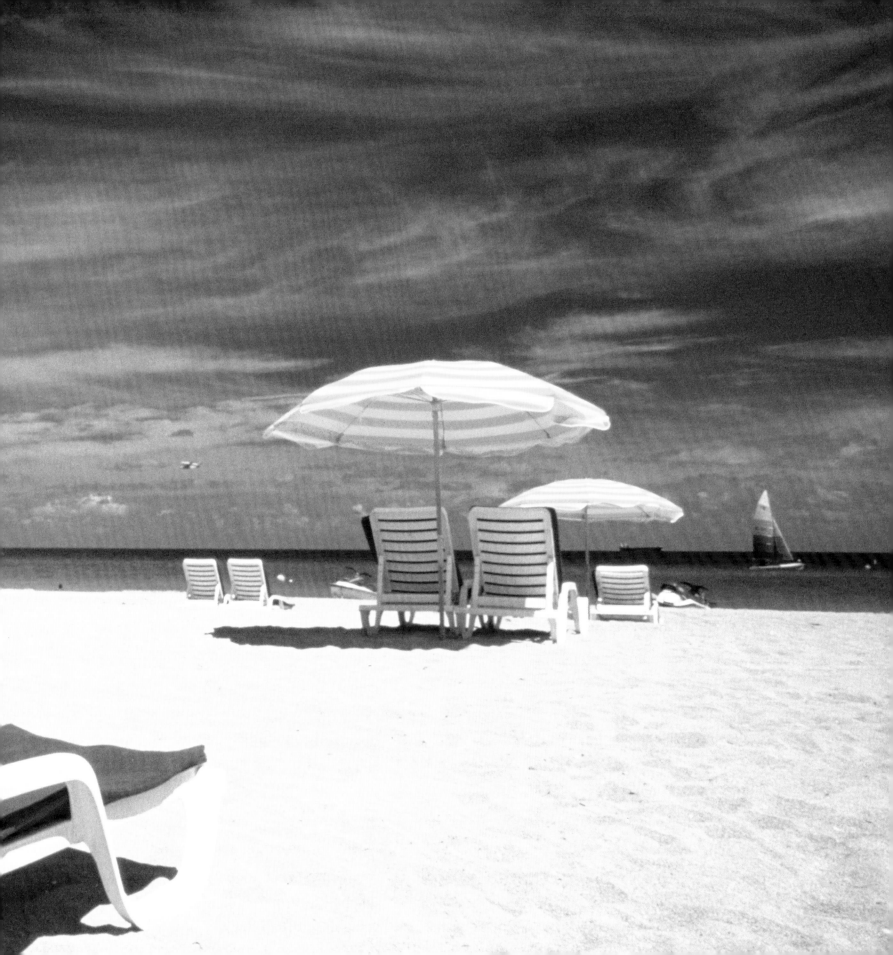

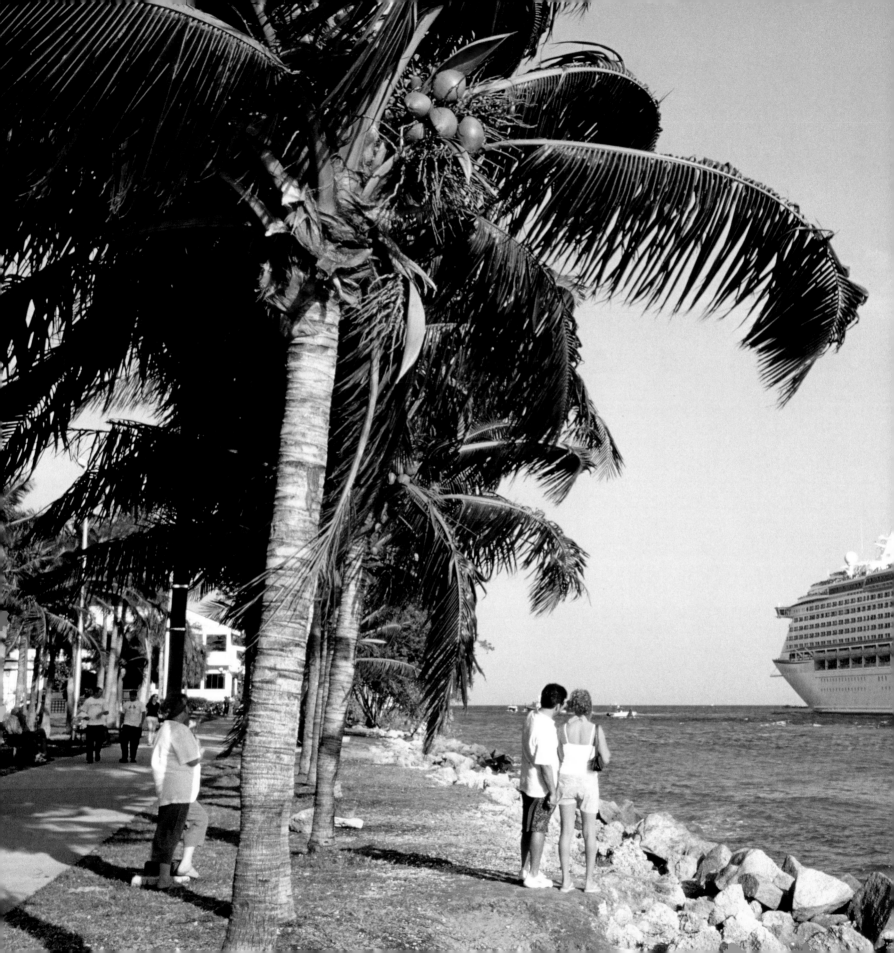

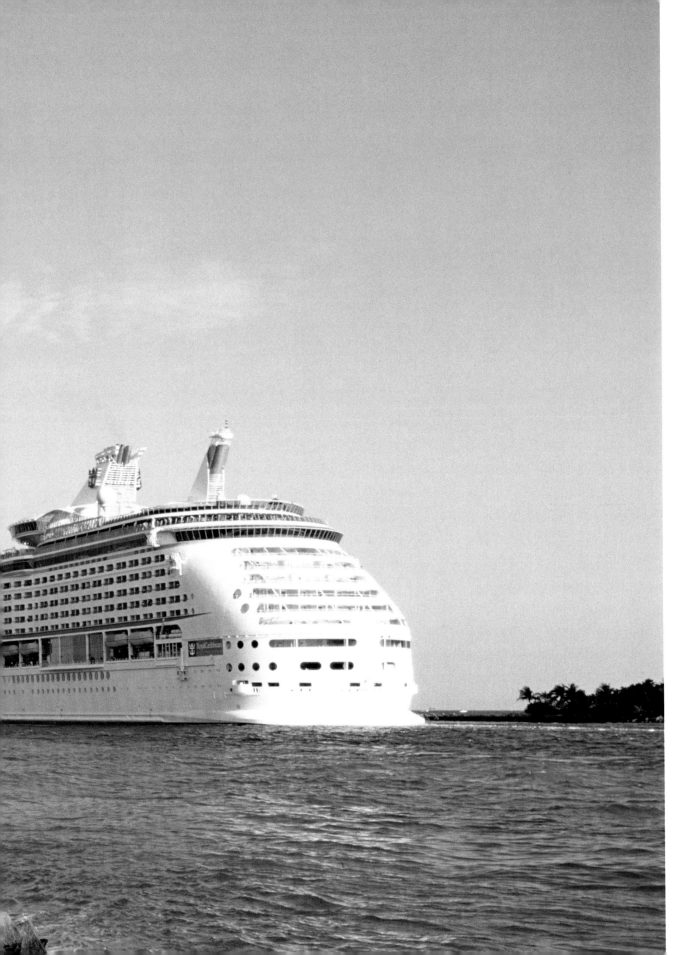

One of Miami Beach's best-kept secrets, South Pointe Park offers extraordinary views of downtown and exclusive Fisher Island.

OVERLEAF
Miami's average temperature is 82.6 degrees in the summer and 67.2 degrees in the winter. This tropical climate draws people to its sandy shores year round.

33

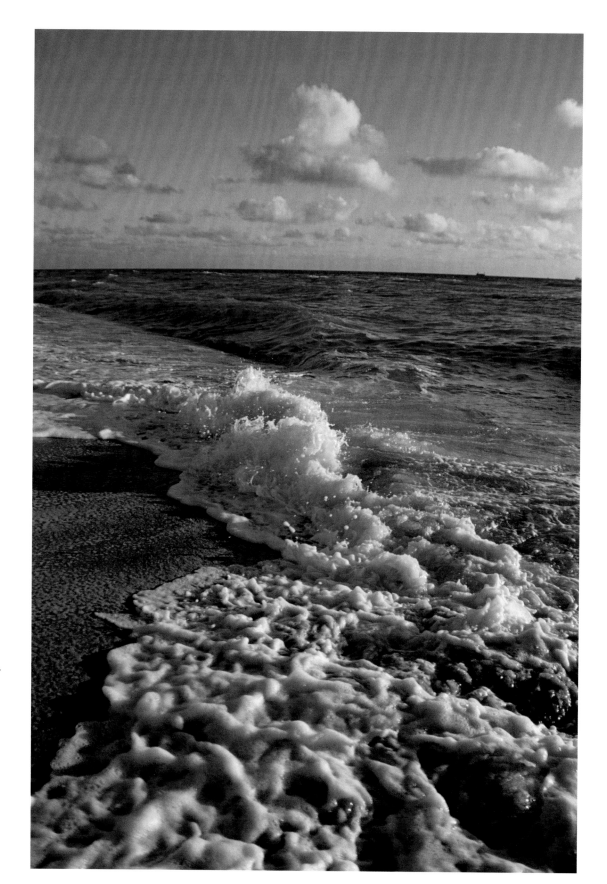

Miami Beach offers a bounty of aquatic activities. Surfing, snorkeling, scuba diving, and boating are the most popular pursuits. Cigarette boats, kayaks, sailboats, and canoes are just a few of the many watercraft spotted frolicking on the waters.

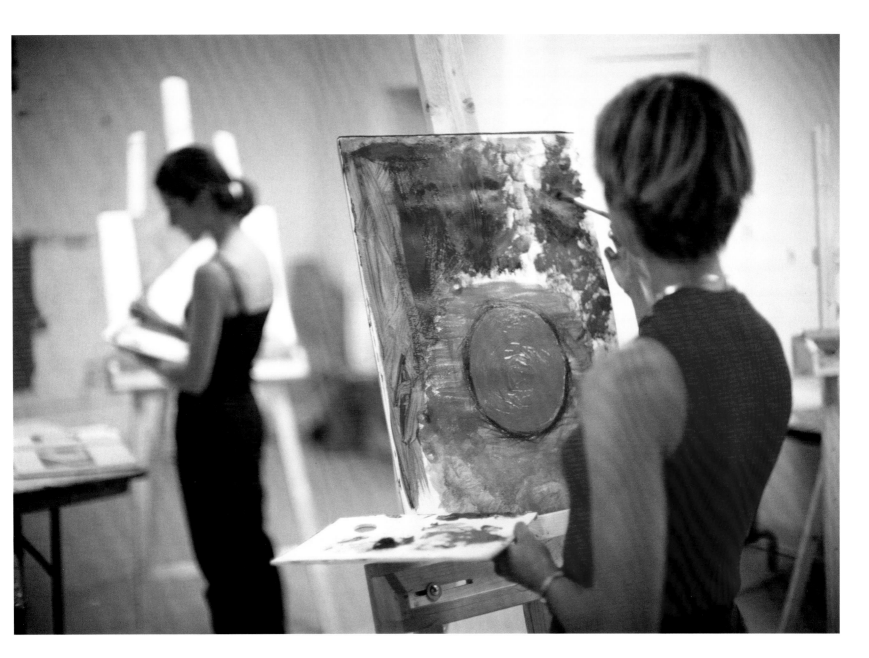

The Artcenter South Florida, in Miami Beach, offers classes in painting, drawing, photography, sculpture, and much more.

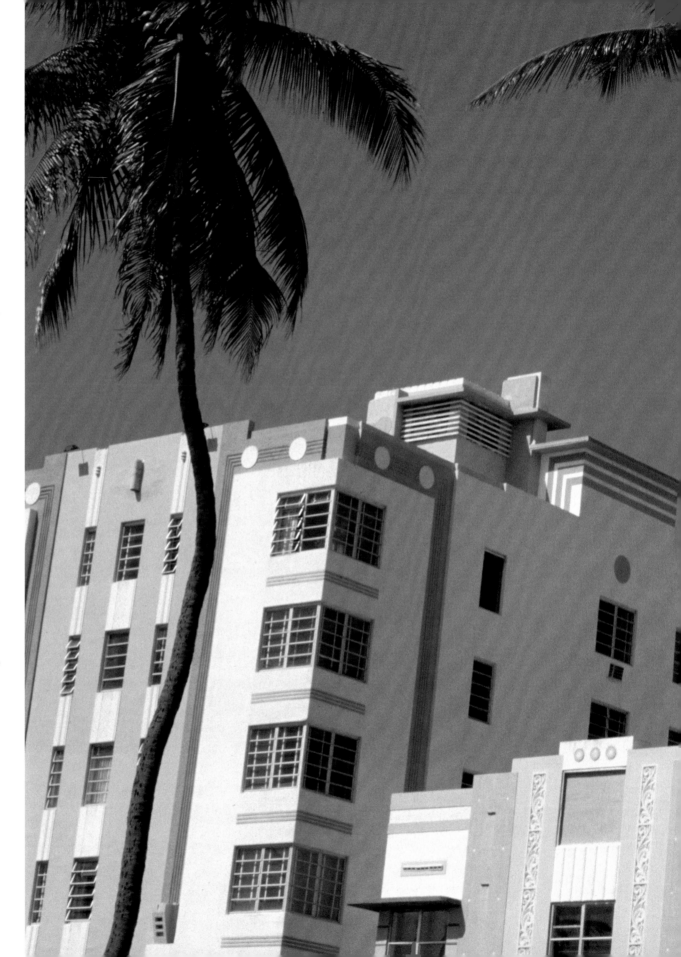

Bright pastel colors, glowing neon signs, and sleek modern lines—just a few characteristics of the more than 800 structures built in South Beach's Art Deco District. Visitors strolling world-famous Ocean Drive will swear they've been transported back in time to the 1930s and '40s.

OVERLEAF
South Beach—Miami Beach's southern stretch of shore—was originally a coconut plantation. Today, the area is known as the "American Riviera," thanks to its tropical beaches, café- and restaurant-lined streets, and bustling nightlife.

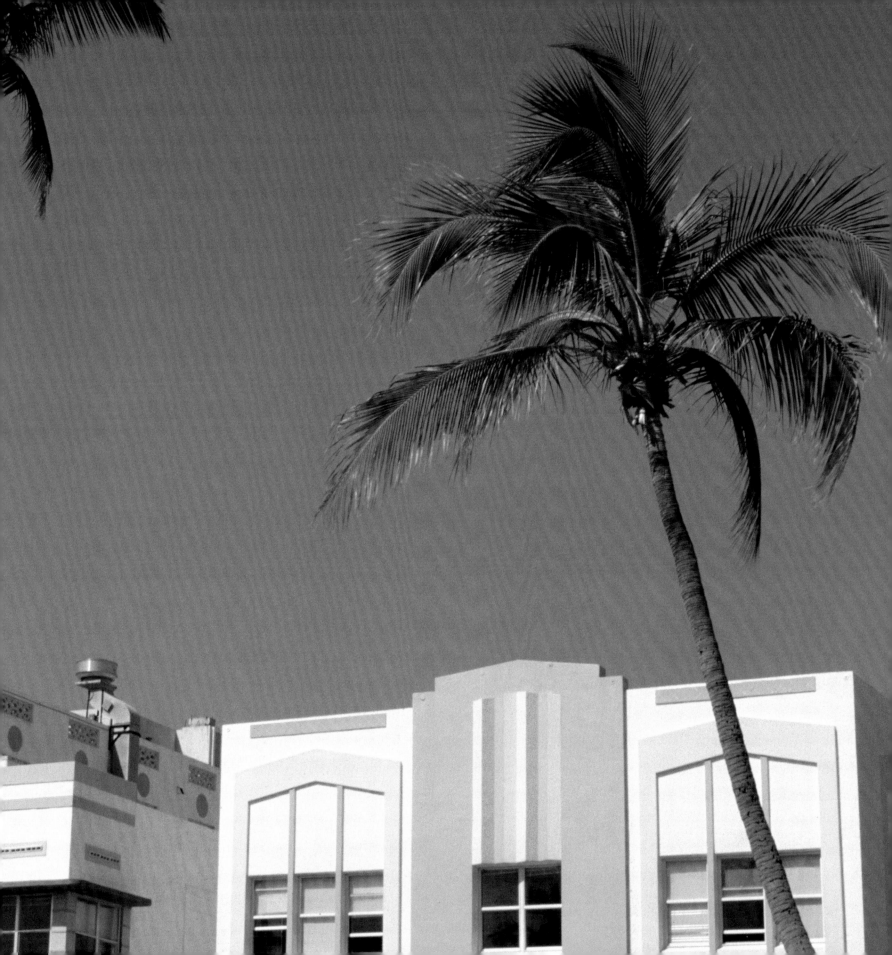

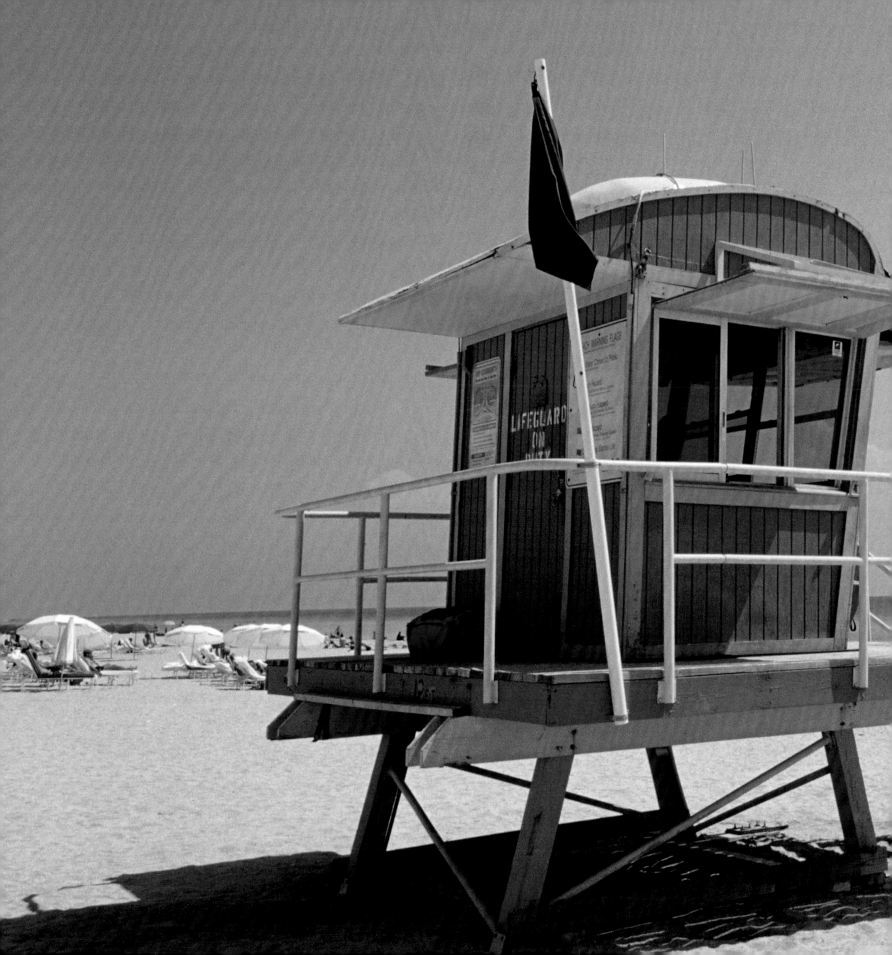

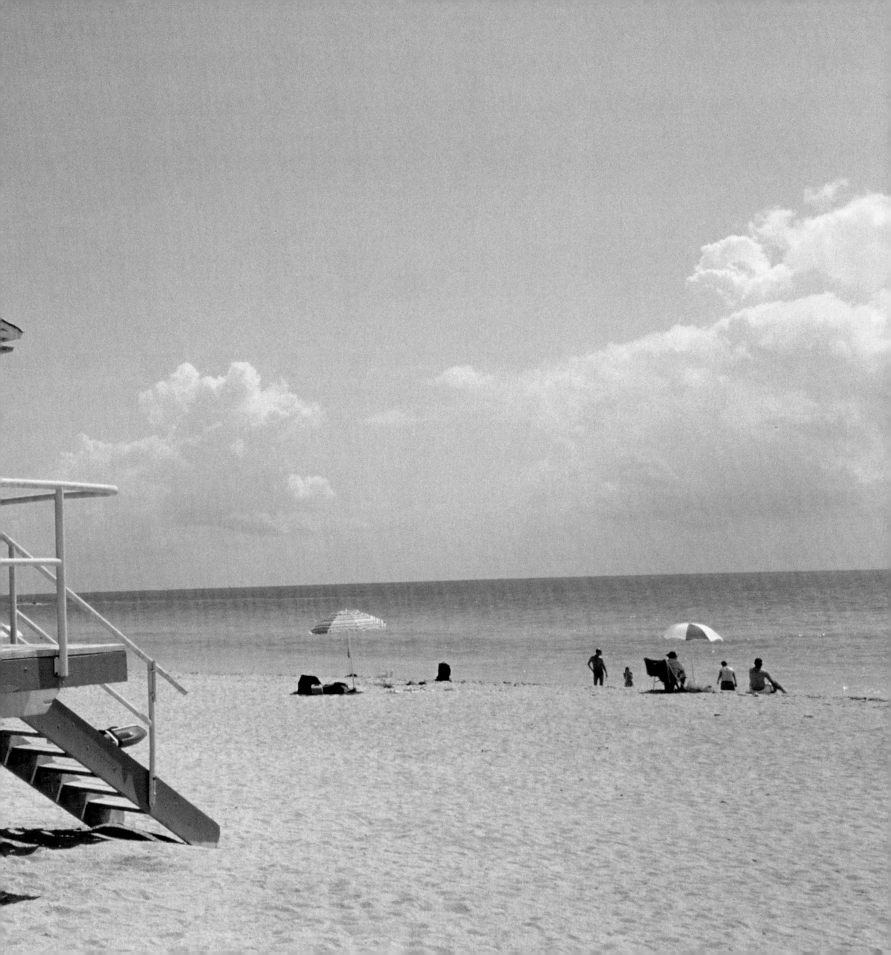

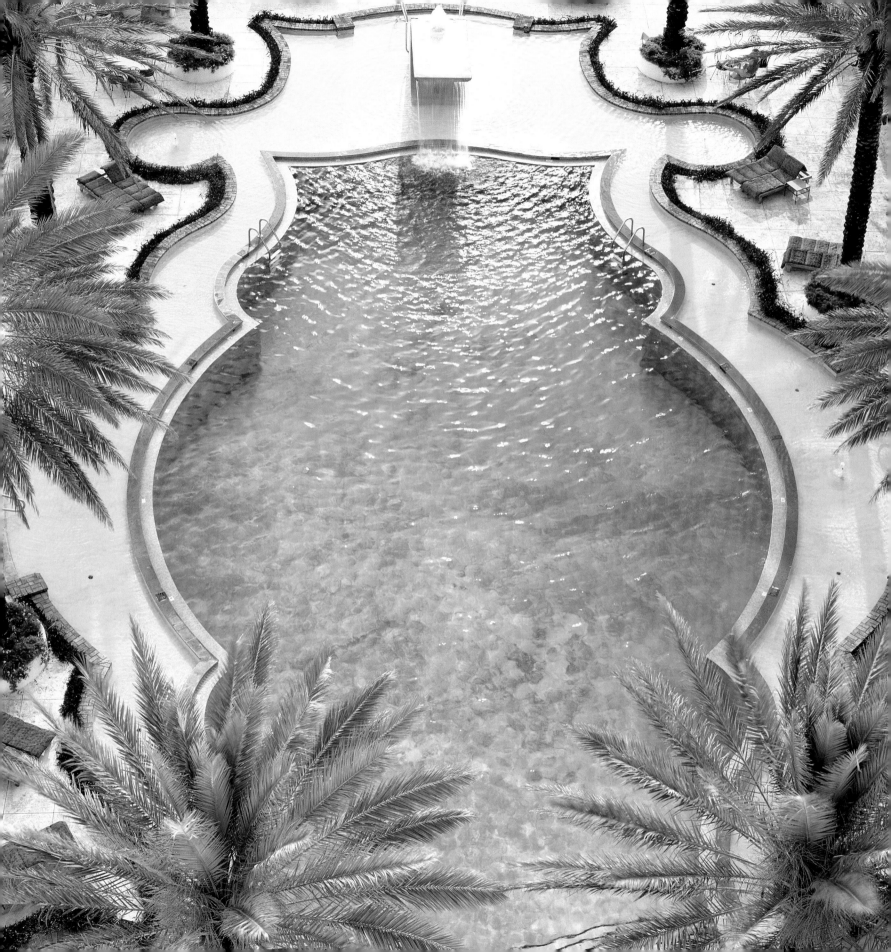

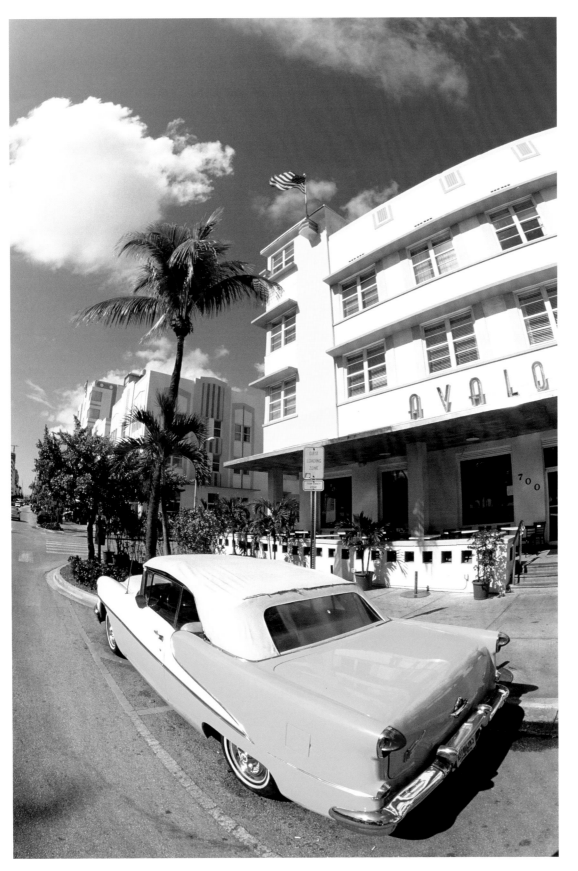

The early 1970s would sadly find South Beach becoming a rather undesirable slum. A revitalization movement spearheaded by Barbara Baer Capitman restored many of the dilapidated art deco buildings to their original splendor. It's now one of the most in-vogue districts in the nation.

FACING PAGE
Poolside at the Raleigh Hotel's art deco lagoon is a place to see and be seen. Trendsetters and tourists can be found sipping cocktails while soaking up the sun.

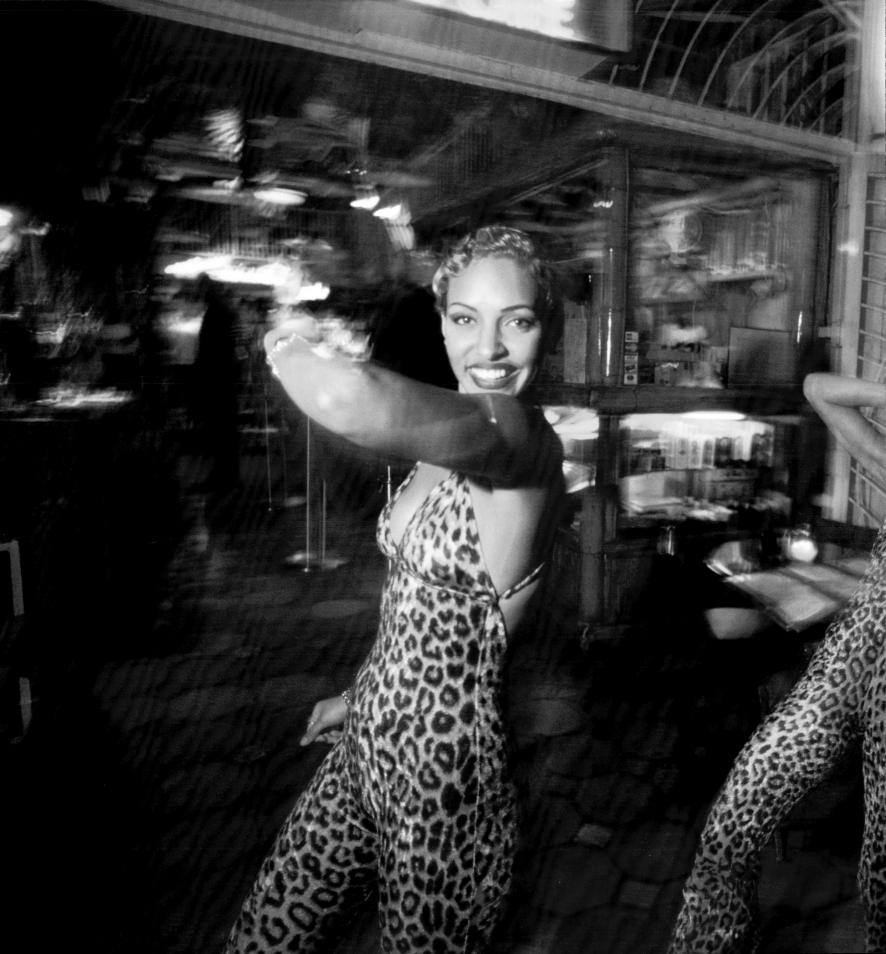

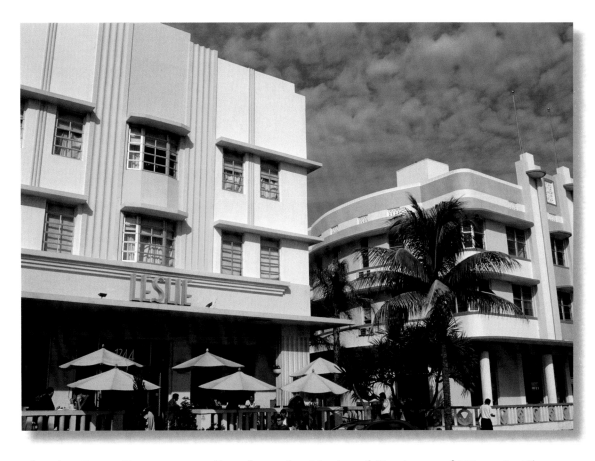

The Art Deco District was listed on the National Register of Historic Places in 1979. It was the nation's first 20th-century Historic District.

South Beach's infamous Ocean Drive is a super-chic destination with unbeatable nightlife. Hipsters, eccentric residents, and visitors alike can enjoy live music, stylish dance clubs, and first-class restaurants.

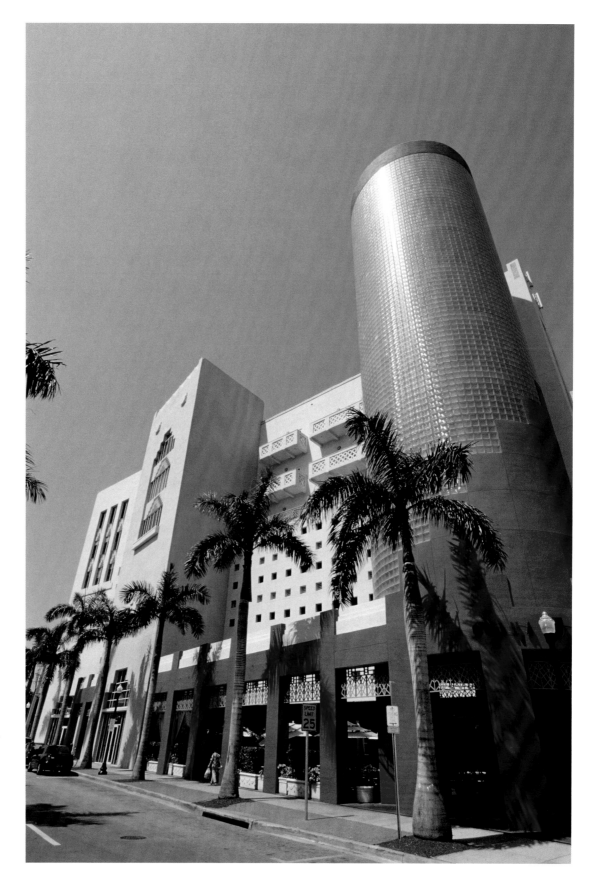

The world's largest glass-block structure, South Beach's 404 Washington Building marries art deco with contemporary design. At night, the glass is illuminated with colors typical of the Art Deco District.

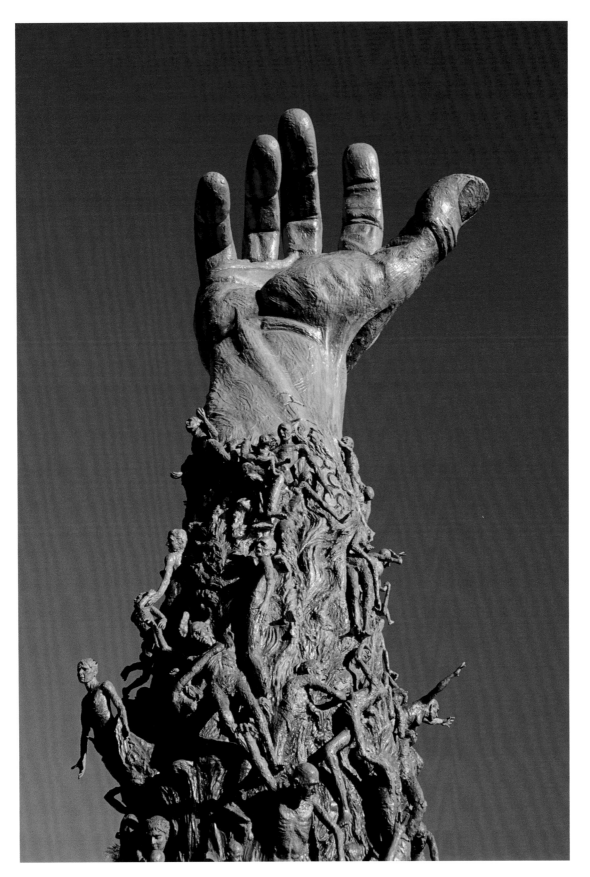

The Holocaust Memorial on Miami Beach opened in February 1990. The memorial is a tribute to Holocaust victims and survivors, and provides a moving educational experience of the horrific tragedy.

OVERLEAF
With a headquarters that looks like a ship's bridge, the Miami Beach Patrol staffs 25 lifeguard stations from South Pointe Park north to 85th Street, making waters safe for swimmers and surfers.

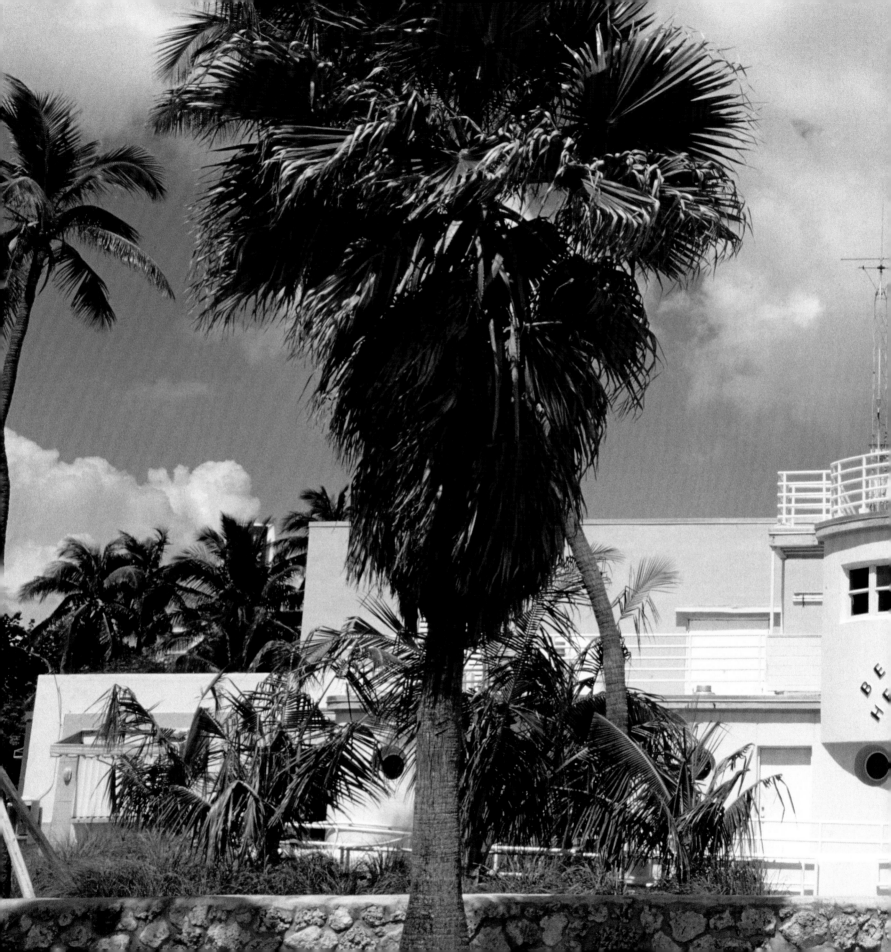

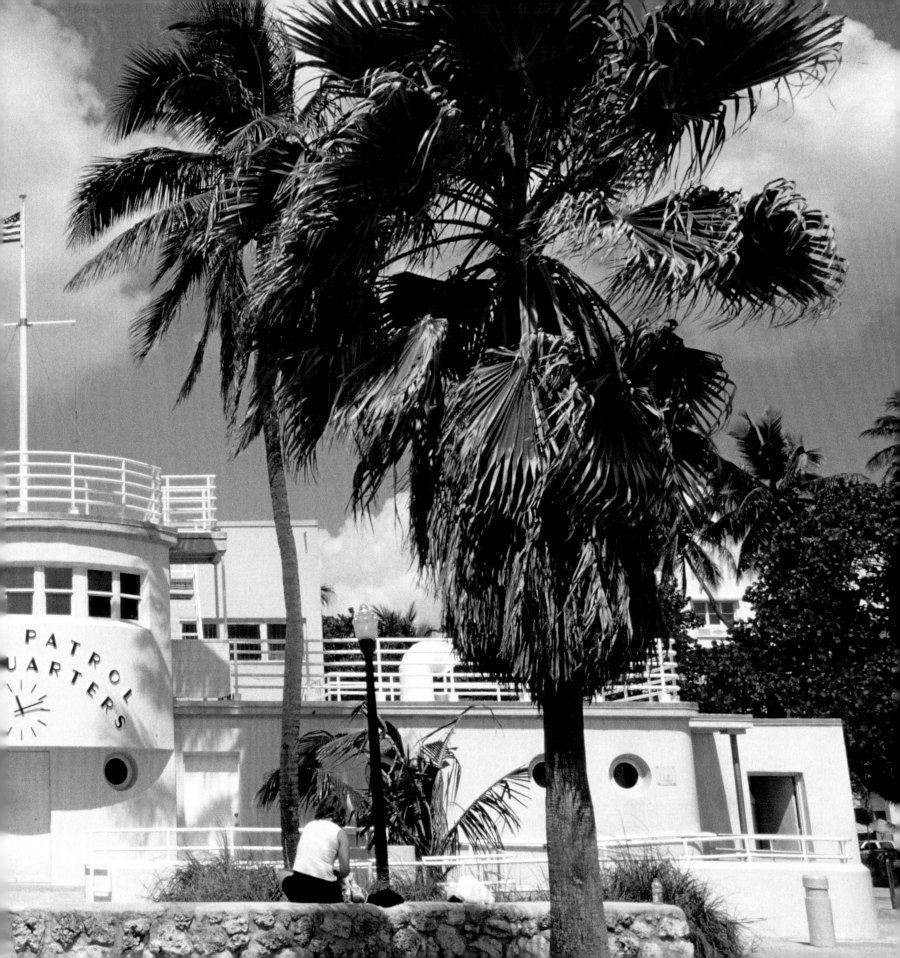

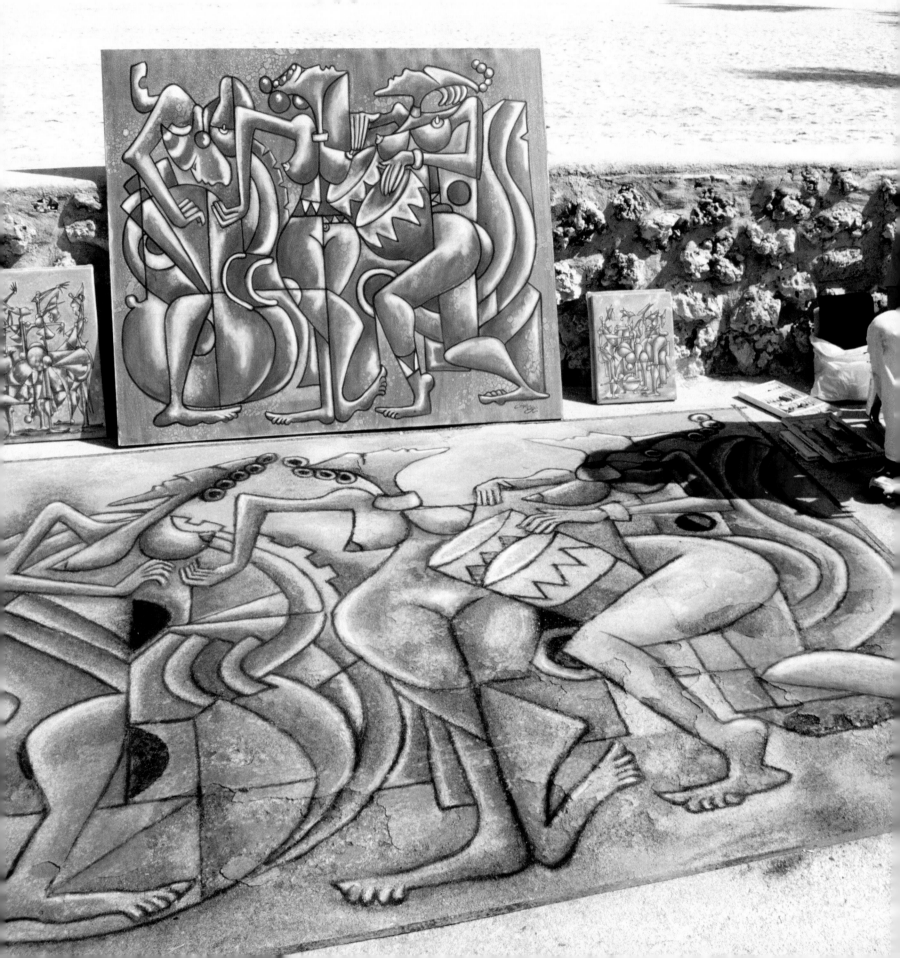

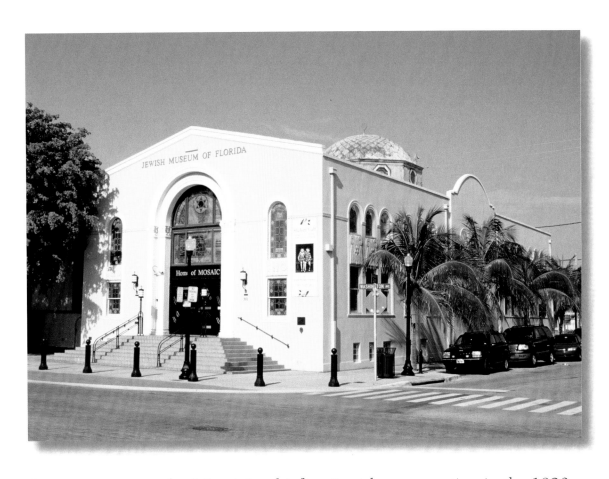

Once a synagogue for Miami Beach's first Jewish congregation in the 1930s, the Jewish Museum of Florida educates the public on the history of Jews in Florida, as well as Jewish culture, tradition, and values.

Developed in 1909, Lummus Park hosts a variety of festivals, including the Miami Beach Fitness Festival. Tourists can explore the park, linger over a picnic, or purchase artwork from one of the many vendors.

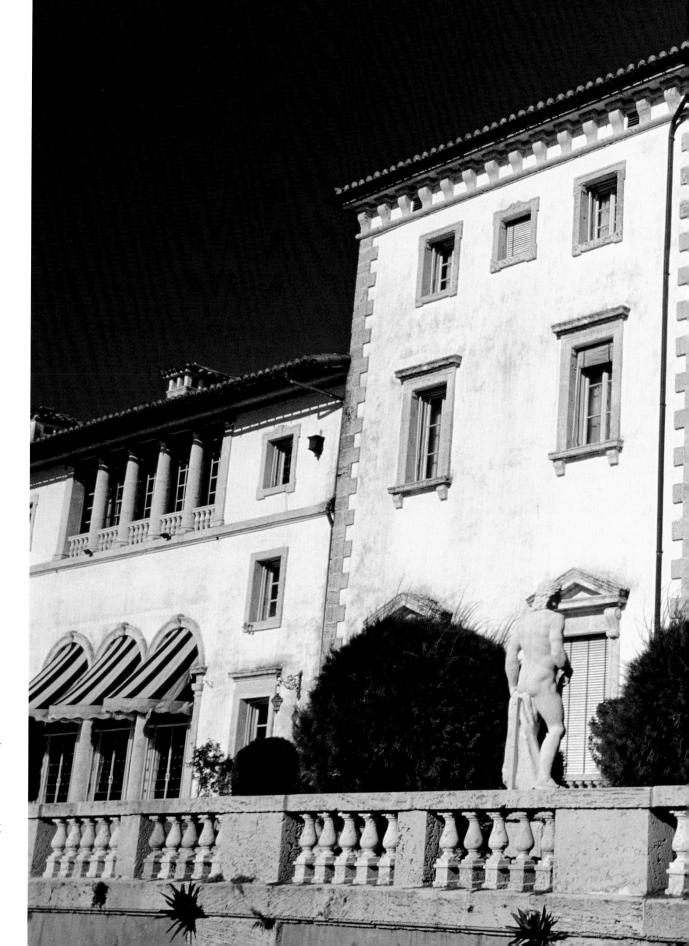

Majestic facades, ornate carvings, manicured gardens, and lavish interiors give the impression of a 400-year-old Italian estate. Vizcaya Villa was actually built as a winter home in 1916 by American industrialist James Deering.

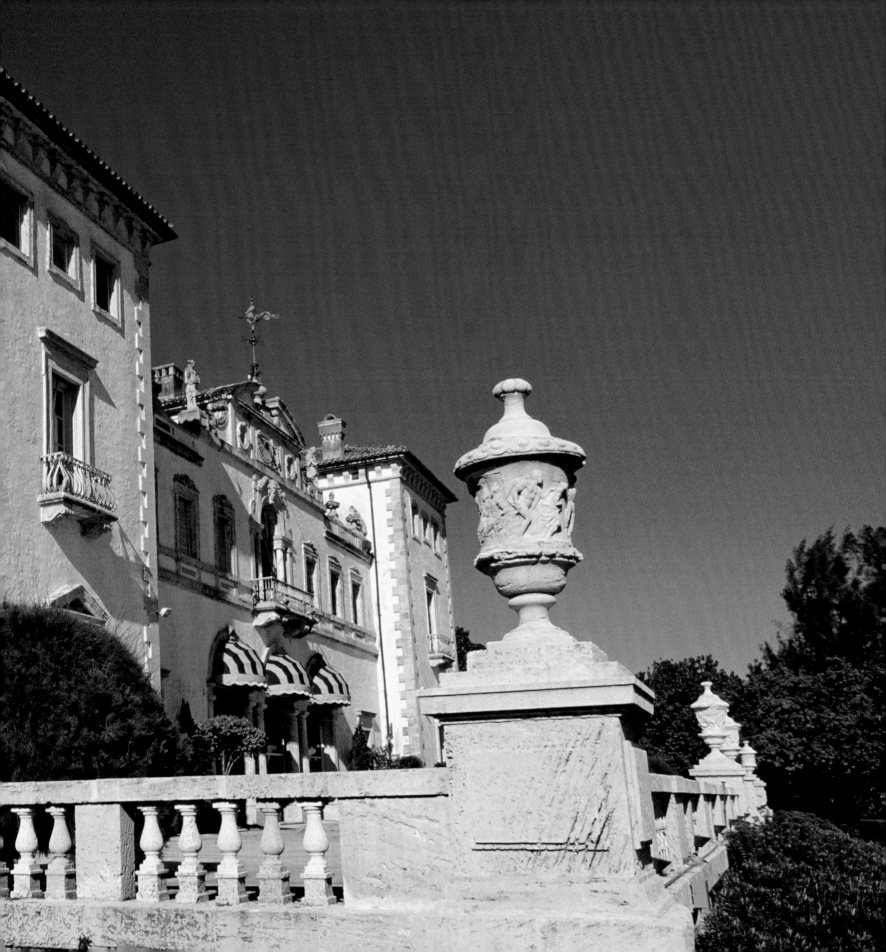

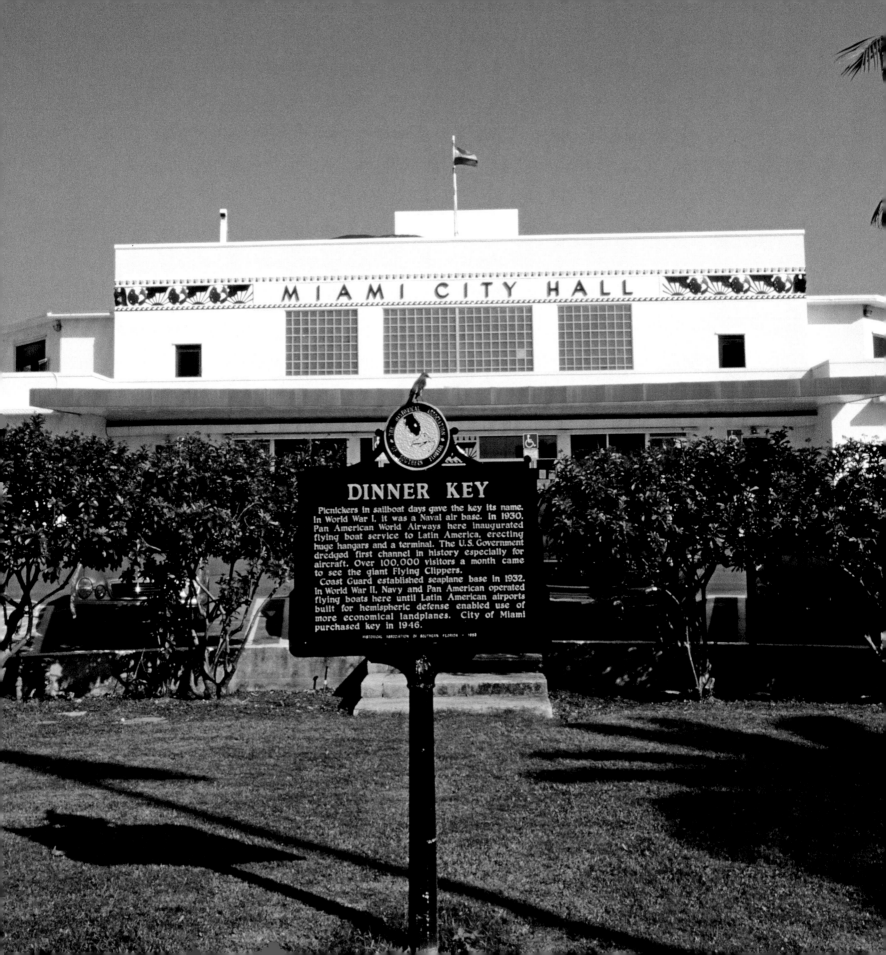

MIAMI CITY HALL

DINNER KEY

Picnickers in sailboat days gave the key its name. In World War I, it was a Naval air base. In 1930, Pan American World Airways here inaugurated flying boat service to Latin America, erecting huge hangars and a terminal. The U.S. Government dredged first channel in history especially for aircraft. Over 100,000 visitors a month came to see the giant Flying Clippers.

Coast Guard established seaplane base in 1932. In World War II, Navy and Pan American operated flying boats here until Latin American airports built for hemispheric defense enabled use of more economical landplanes. City of Miami purchased key in 1946.

HISTORICAL ASSOCIATION OF SOUTHERN FLORIDA · 1993

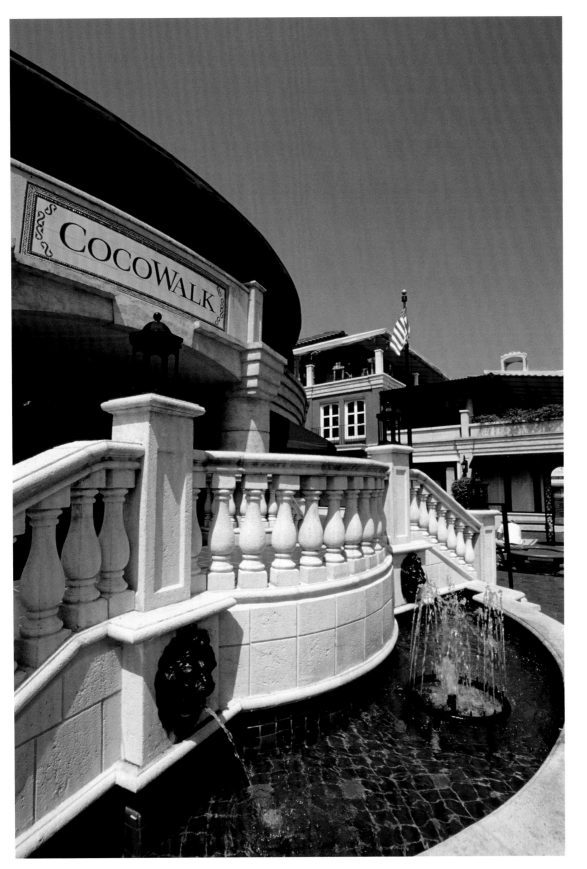

CocoWalk is a lively outdoor shopping enclave with a European village atmosphere. It's filled with charming outdoor cafés, bistros, and shops.

FACING PAGE
The verdurous landscape and sedate bayshore setting of Coconut Grove attracted artists the world over in the 1950s. By the 1960s, the streets were lined with galleries, and it was common to see artists setting up their easels on the sidewalks. Today, the Coconut Grove Arts Festival is one of the leading art festivals in the country.

From 1821 to 1896, Miami was accessible only by boat. Few ventured into the shallow but treacherous waters of Biscayne Bay. Commodore Ralph Munroe was one of the industrious pioneers who settled the area. The serene Barnacle Historic Site, located in bustling Coconut Grove, preserves his homestead and offers a glimpse into the early days of the region.

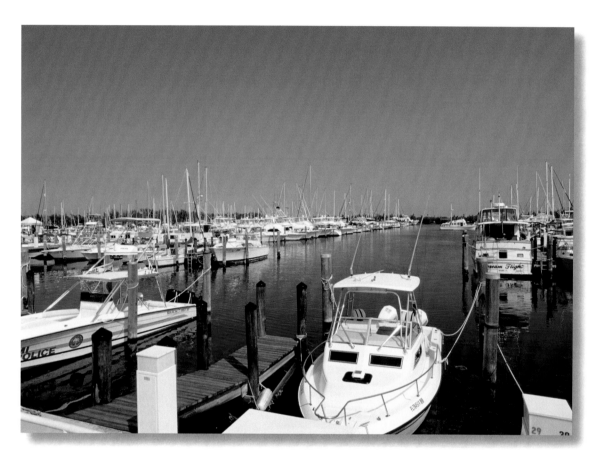

Coconut Grove's Dinner Key Marina—Florida's largest marine facility—can accommodate over 580 boats. Originally a base for Pan Am's flying boats, the Clippers, the marina accommodates seasonal and live-aboard mariners.

The Coconut Grove Playhouse, originally built as a movie house in 1926, was converted into a stage theater 30 years later. It has earned a reputation worthy of its nickname, Broadway by the Bay.

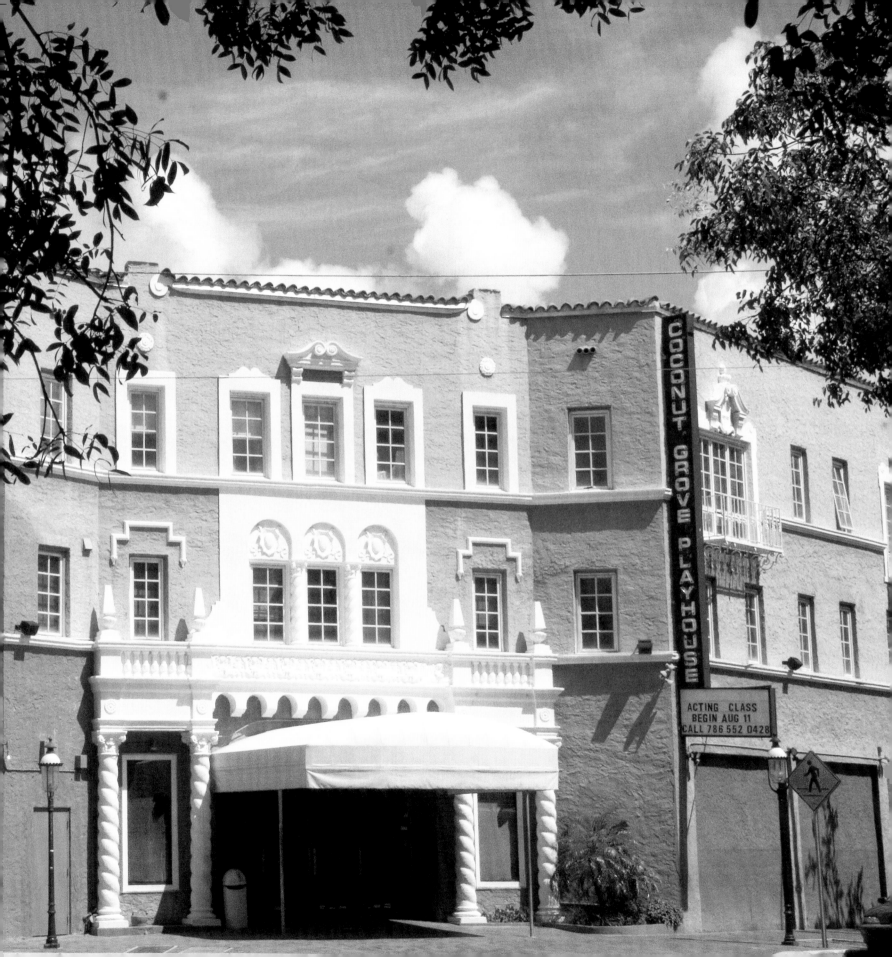

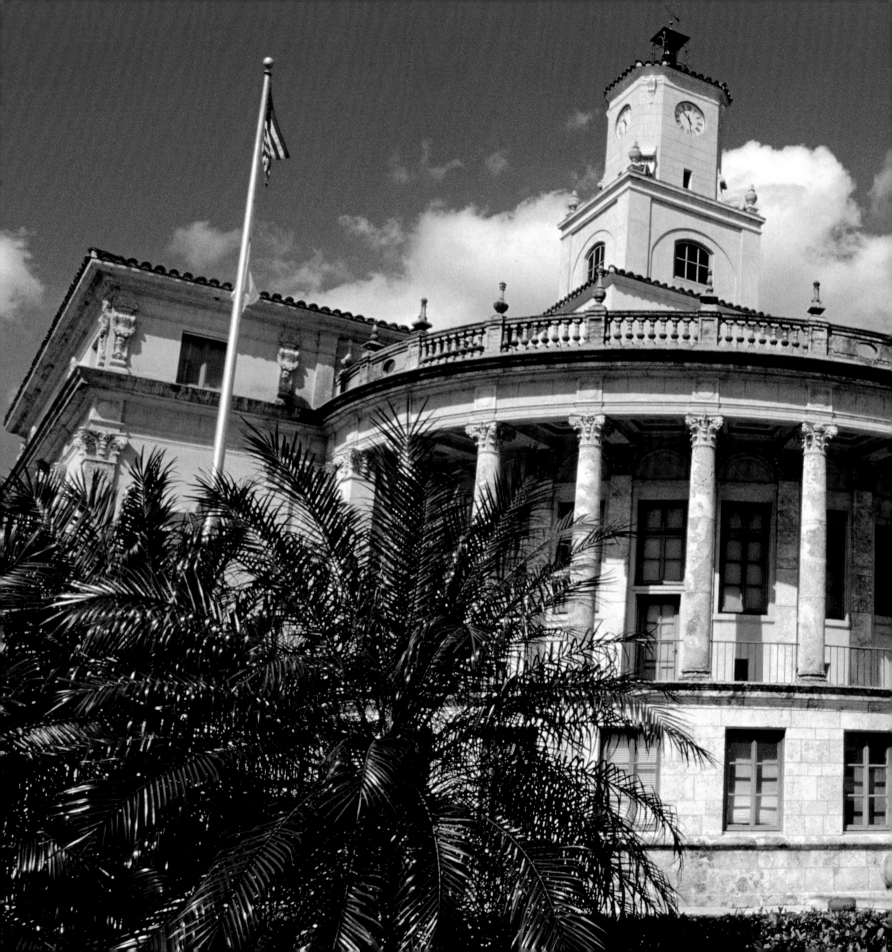

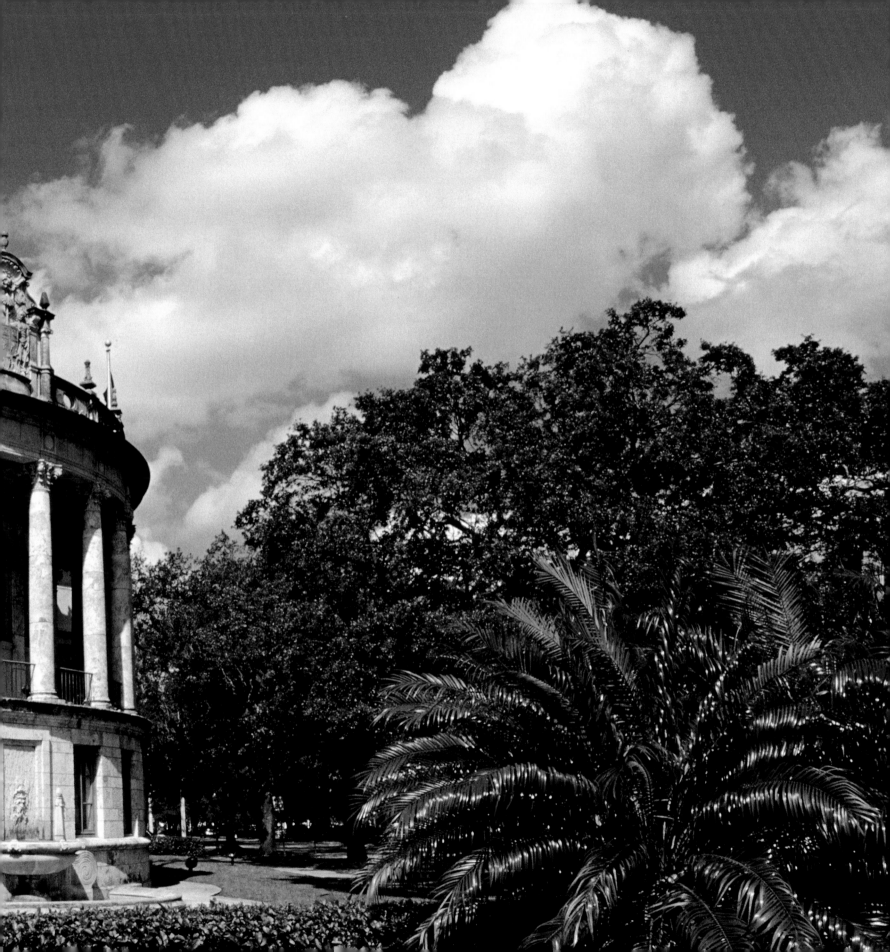

Coral Gables was designed in the Mediterranean Revival style—complete with coral archways, lush gardens, plazas, esplanades, and criss-crossing canals.

PREVIOUS PAGE
Coral Gables' ornate City Hall—designed by architect Phineas Paist—is constructed largely of coral rock. Its tower interior houses a mural by painter Denman Fink depicting the four seasons.

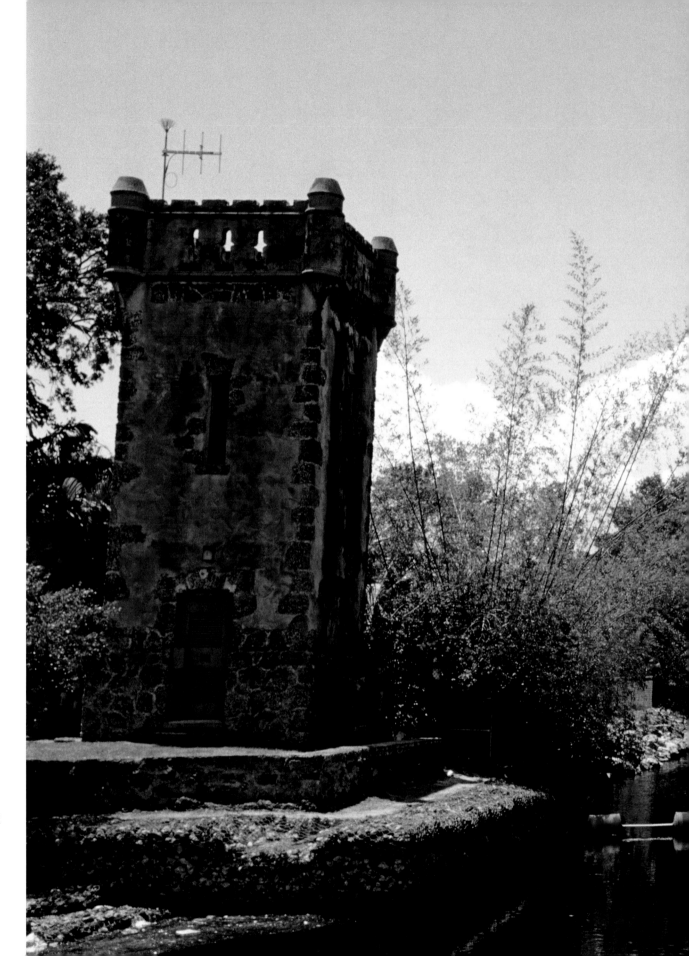

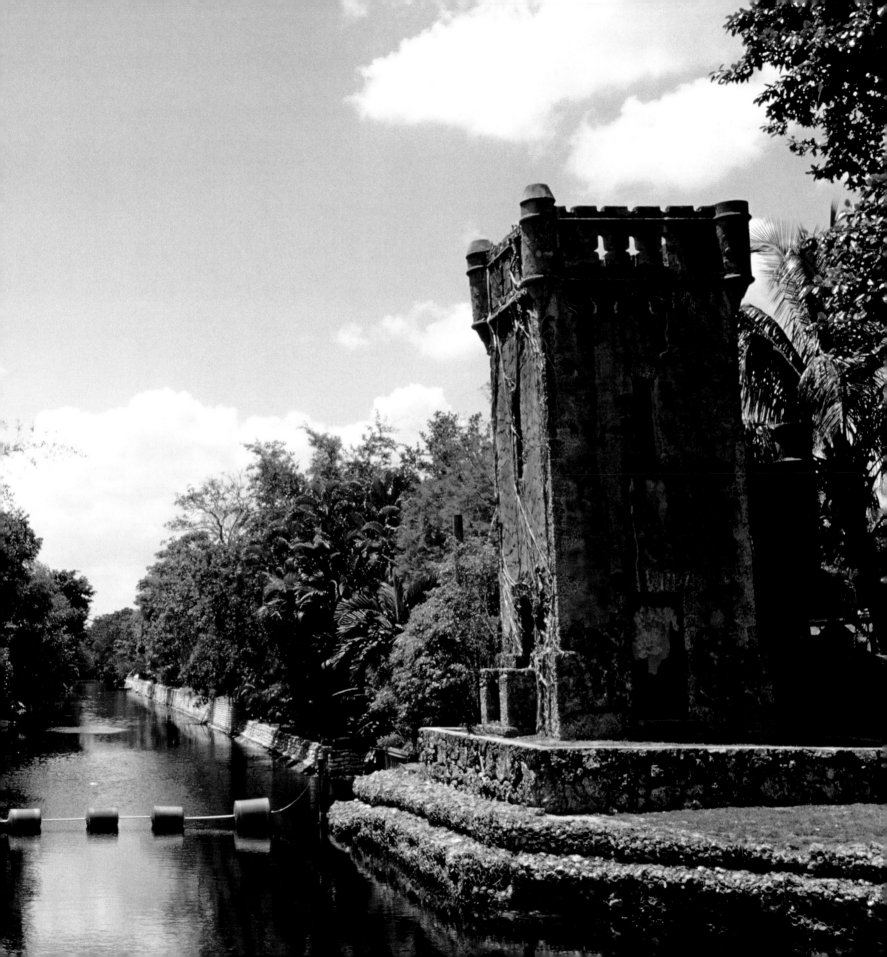

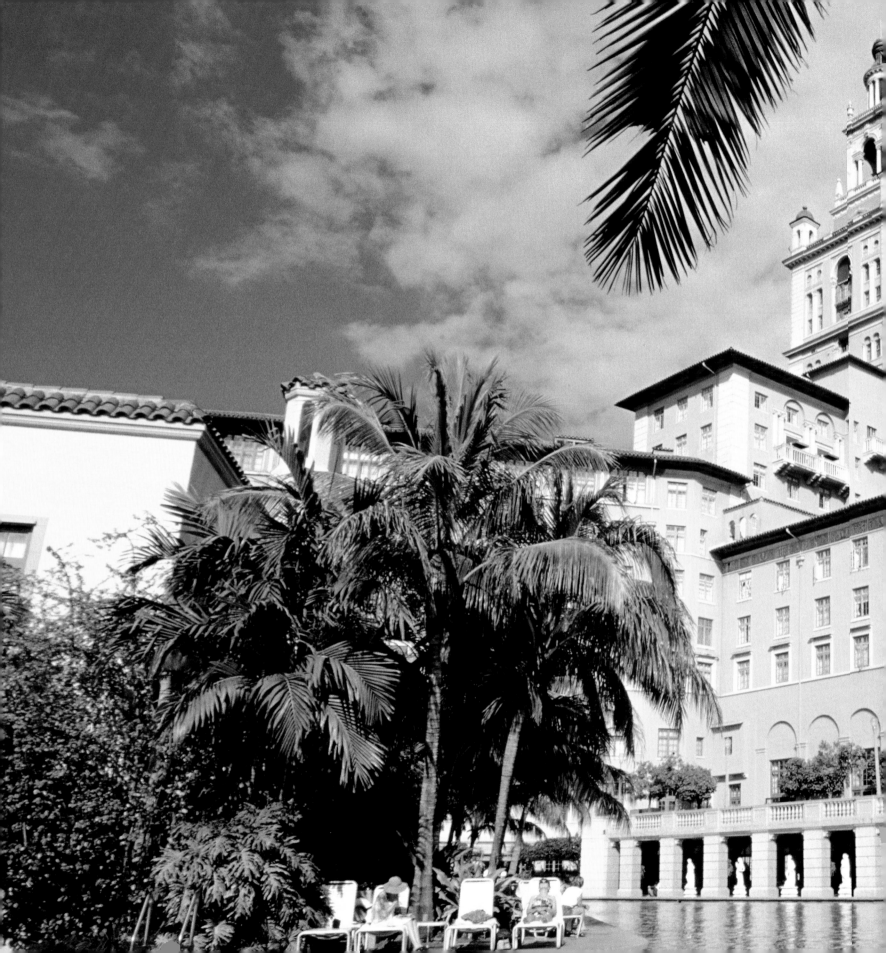

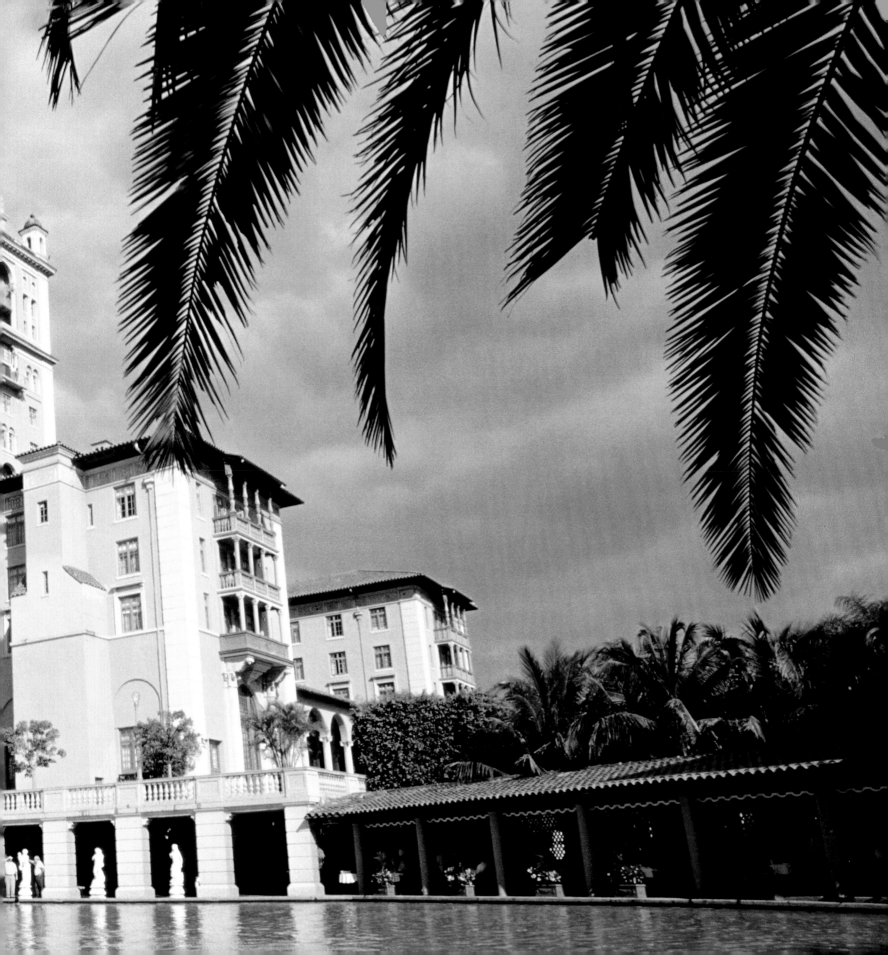

Completed in 1926 by George Merrick, Coral Gables was one of the country's first fully planned communities.

PREVIOUS PAGE
Coral Gables' lavish Biltmore Hotel offers 280 luxurious rooms. Until the 1930s, the hotel's pool—the largest in the continental United States—hosted an array of aquatic galas, featuring bathing beauties, alligator wrestling, and Jackie Ott, the boy wonder who dove from an 85-foot platform. Converted into a hospital during World War II, it re-opened as a hotel in 1987.

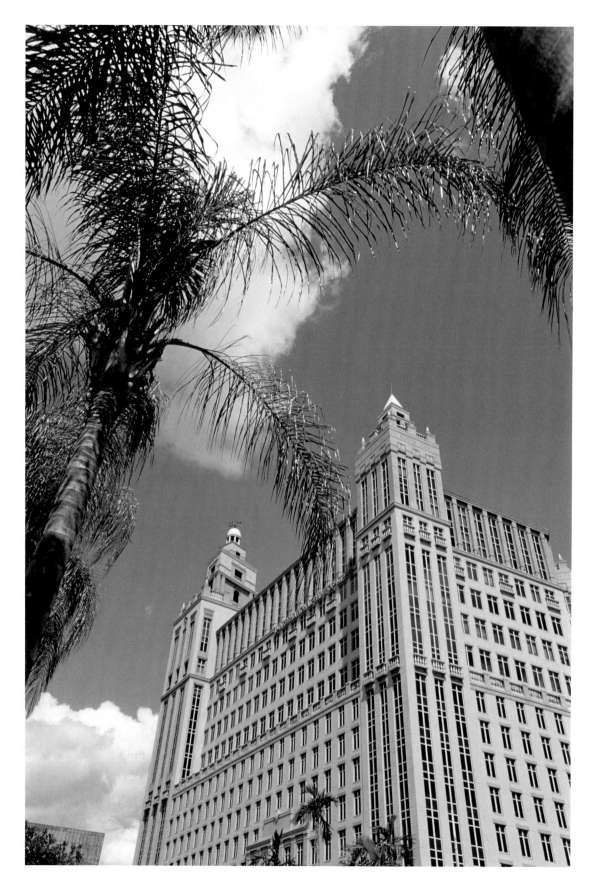

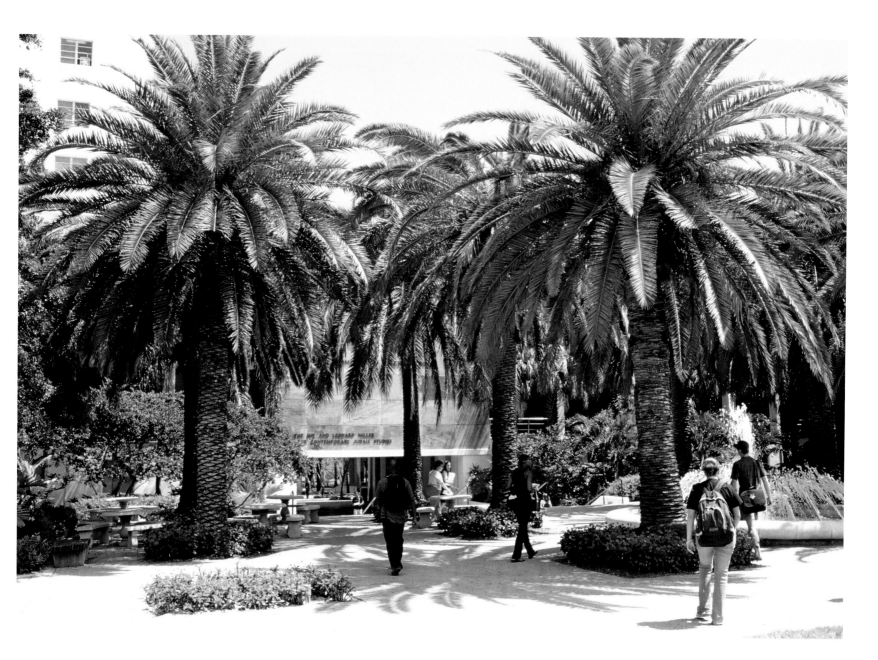

More than 15,000 students enjoy the tropical setting of the University of Miami's campus. Founded in 1925, the university attracts students from across the nation and from more than 100 different countries.

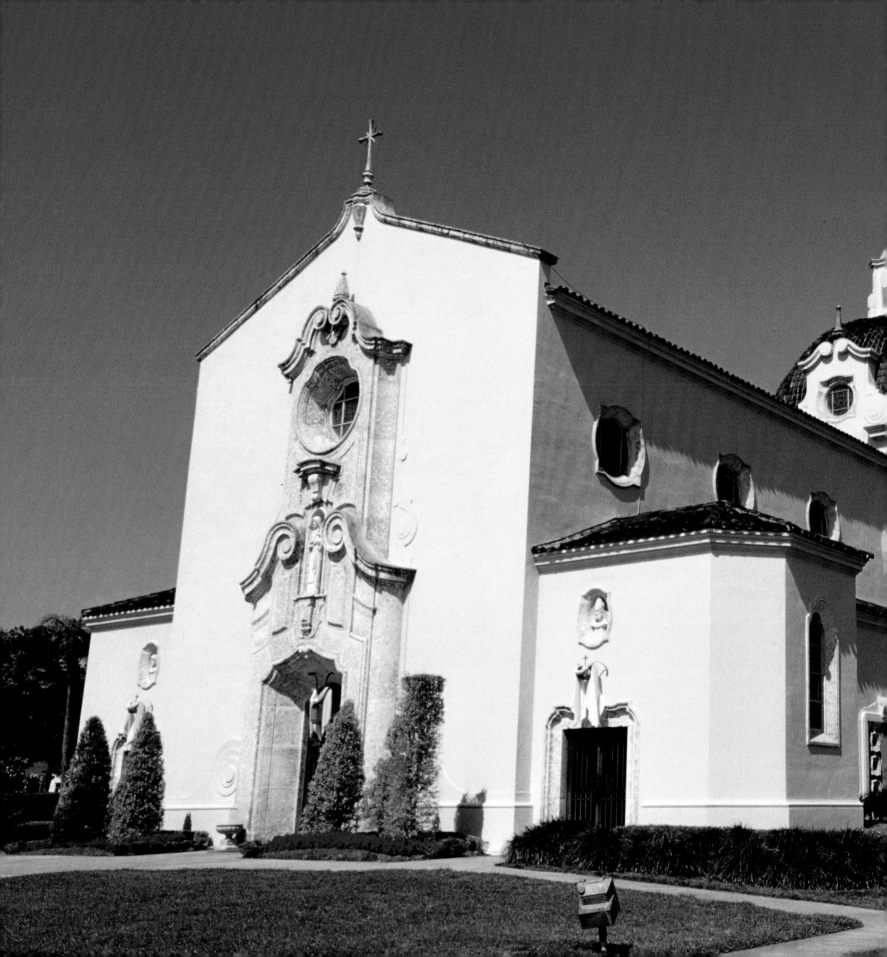

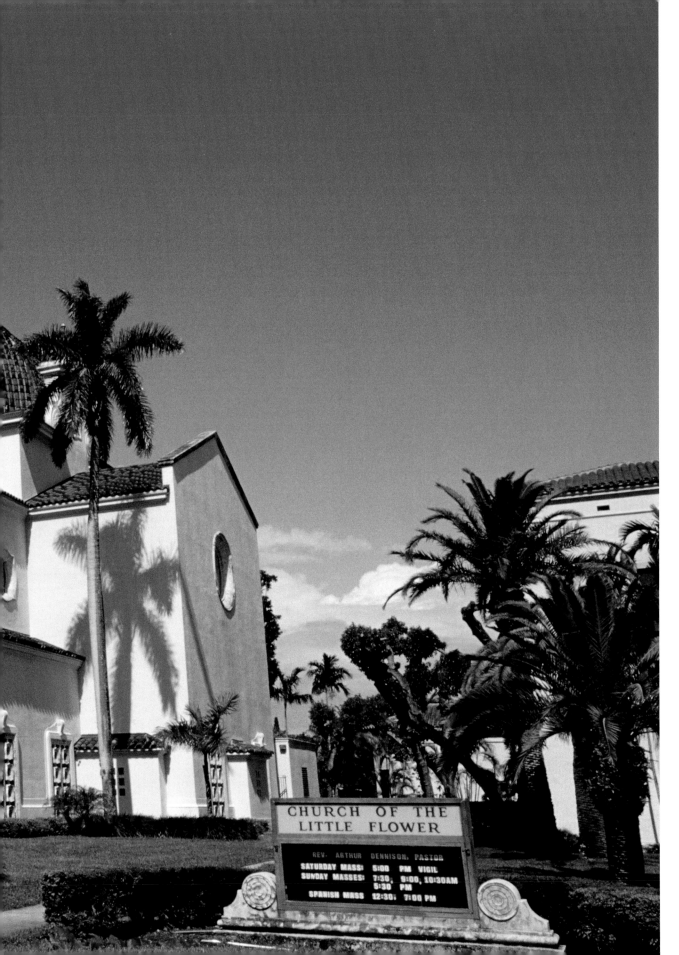

CHURCH OF THE
LITTLE FLOWER

REV. ARTHUR DENNISON, PASTOR
SATURDAY MASS: 5:00 PM VIGIL
SUNDAY MASSES: 7:30, 9:00, 10:30AM
5:30 PM
SPANISH MASS 12:30: 7:00 PM

Dedicated to Saint
Theresa—one
of the principal
saints of Roman
Catholicism—the
Church of the Little
Flower was built
in Coral Gables in
1925.

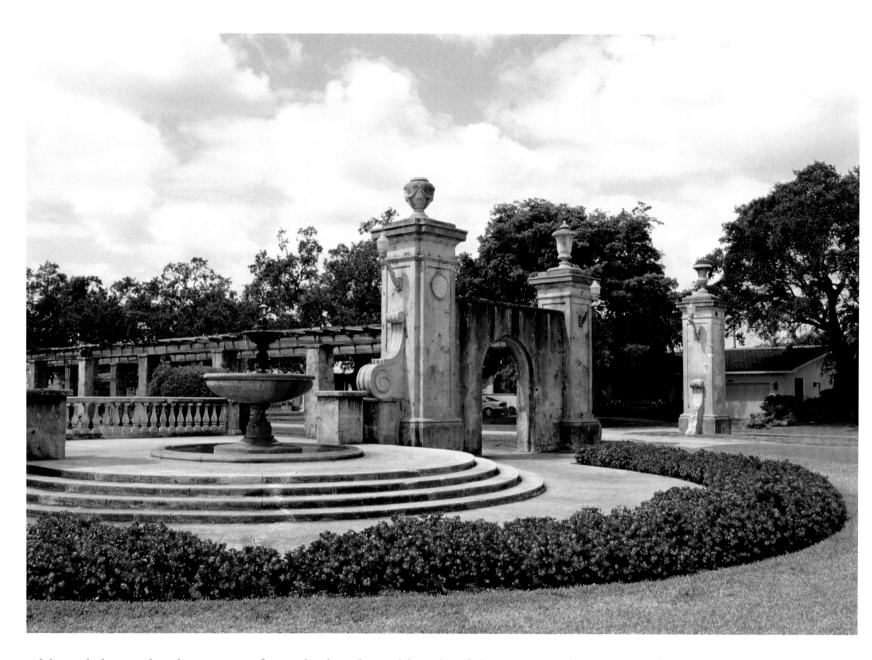

Although located only minutes from the hustle and bustle of downtown, the tree-lined, landscaped boulevards of Coral Gables' residential and commercial enclaves evoke images of a picturesque Mediterranean village.

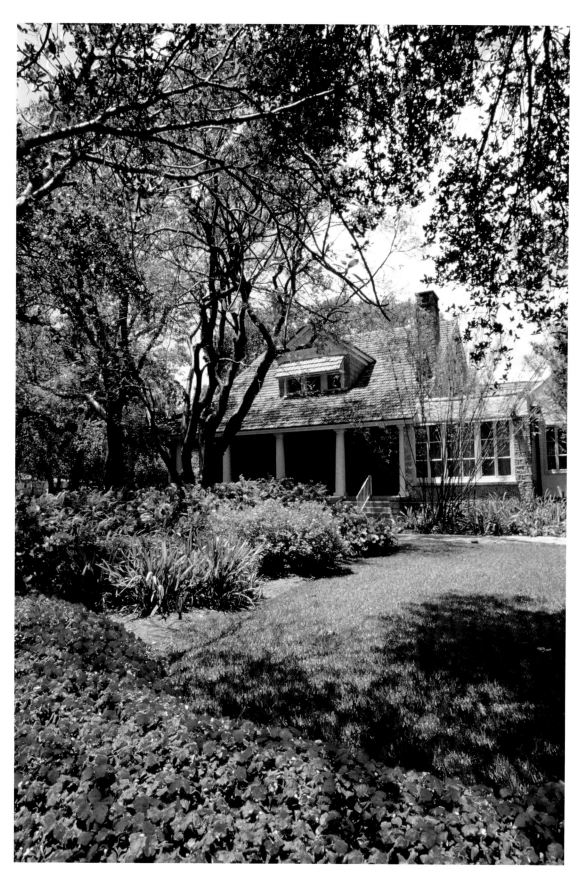

Coral Gables' Merrick House preserves the boyhood home of the community's founder and architect, George Merrick.

OVERLEAF
Originally a coral rock quarry, the Venetian Pool—with its cascading waterfalls, coral caves, vine-covered walls, and majestic fountains—attracts more than 100,000 visitors each year. The pool's 800,000 gallons of fresh water are purified nightly by an aquifer beneath it.

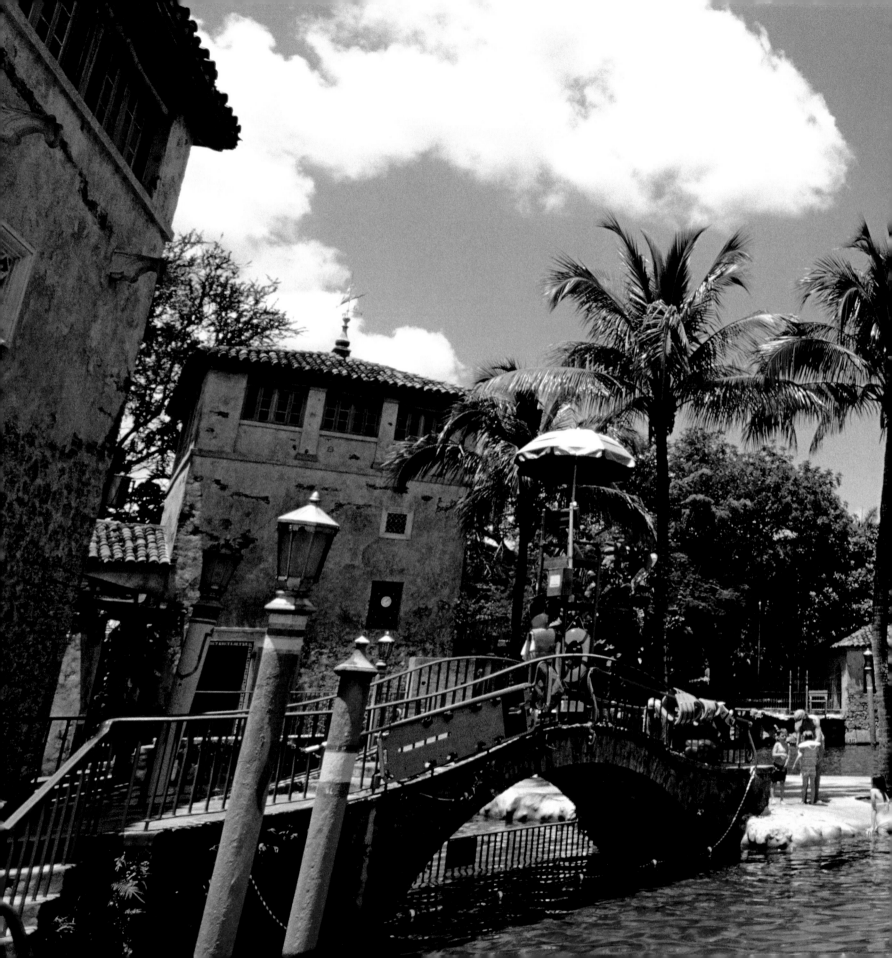

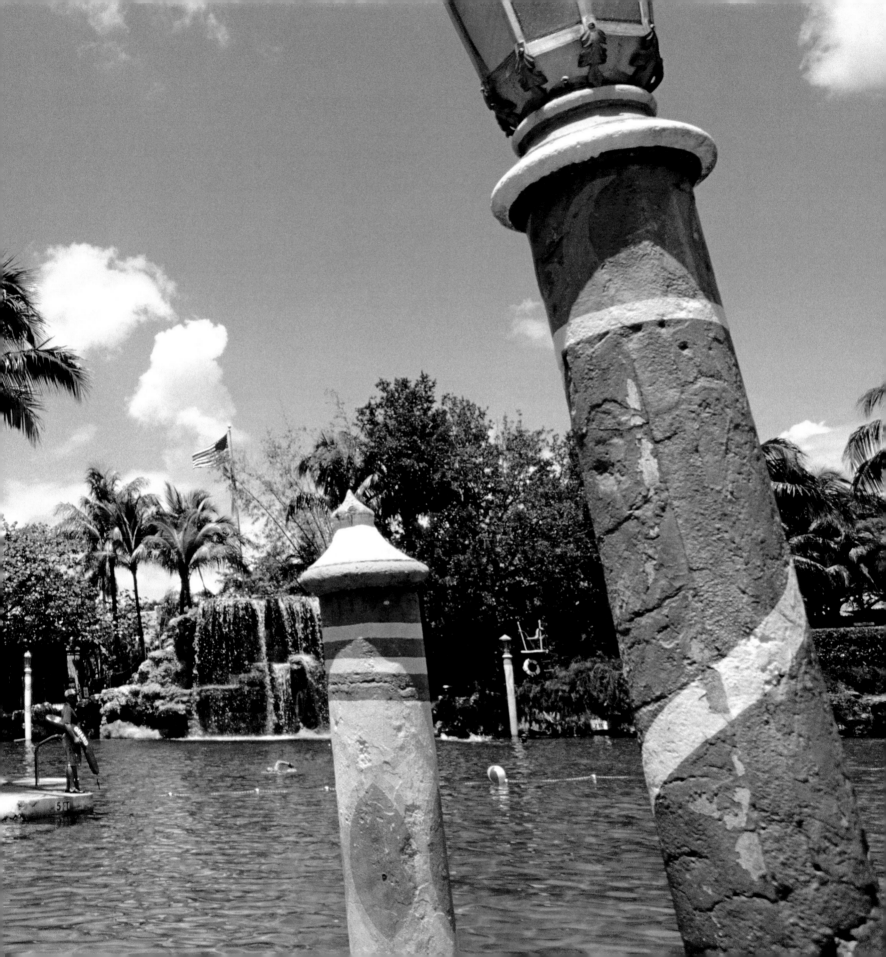

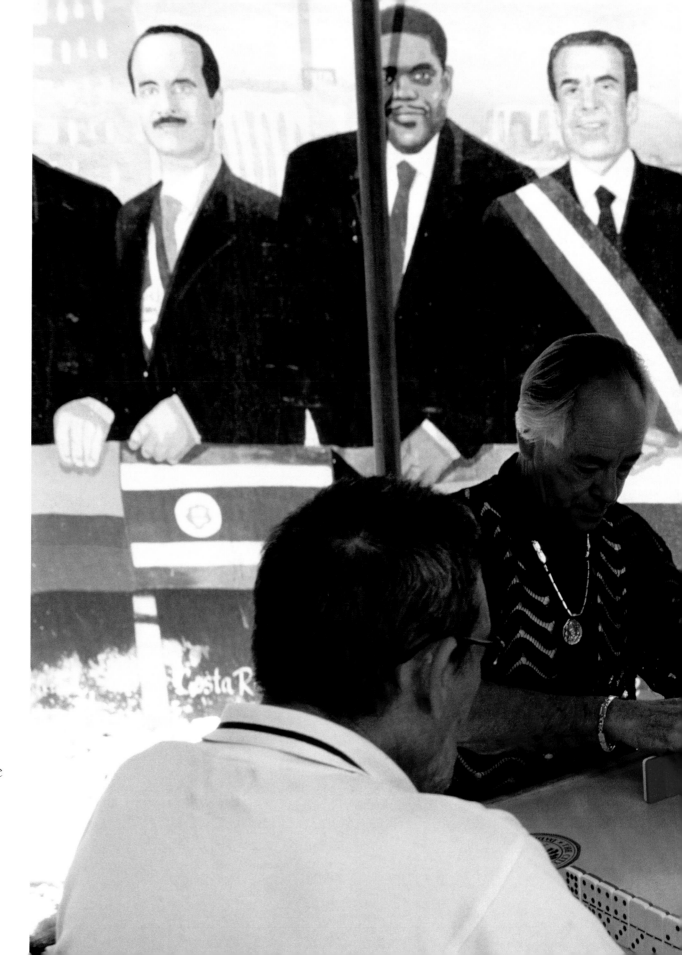

In Maximo
Gomez Park, or
Domino Park, as
the locals call it,
elder generations of
Cuban-Americans
meet to play chess
or dominoes and
discuss politics.

OVERLEAF
The Cuban Revolu-
tion's impact was
not limited to Cuba.
The city of Miami
changed drastically
as more than half
a million Cubans
relocated here. The
largest concentra-
tion of Cubans, Little
Havana, is a vibrant
enclave steeped in
energetic and color-
ful Hispanic culture.

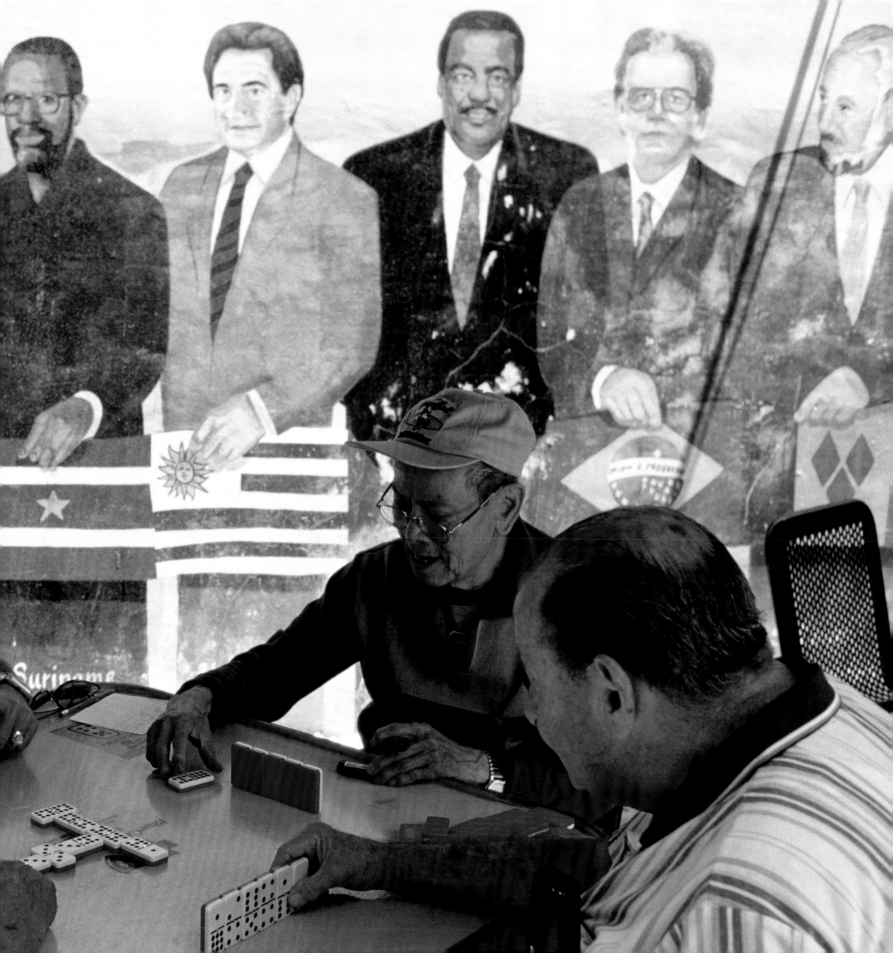

Pulsating music, vibrant meat markets and *fruterias*, unique art galleries and authentic restaurants—walking down Little Havana's Eighth Street, or Calle Ocho, feels like a time warp into old Cuba.

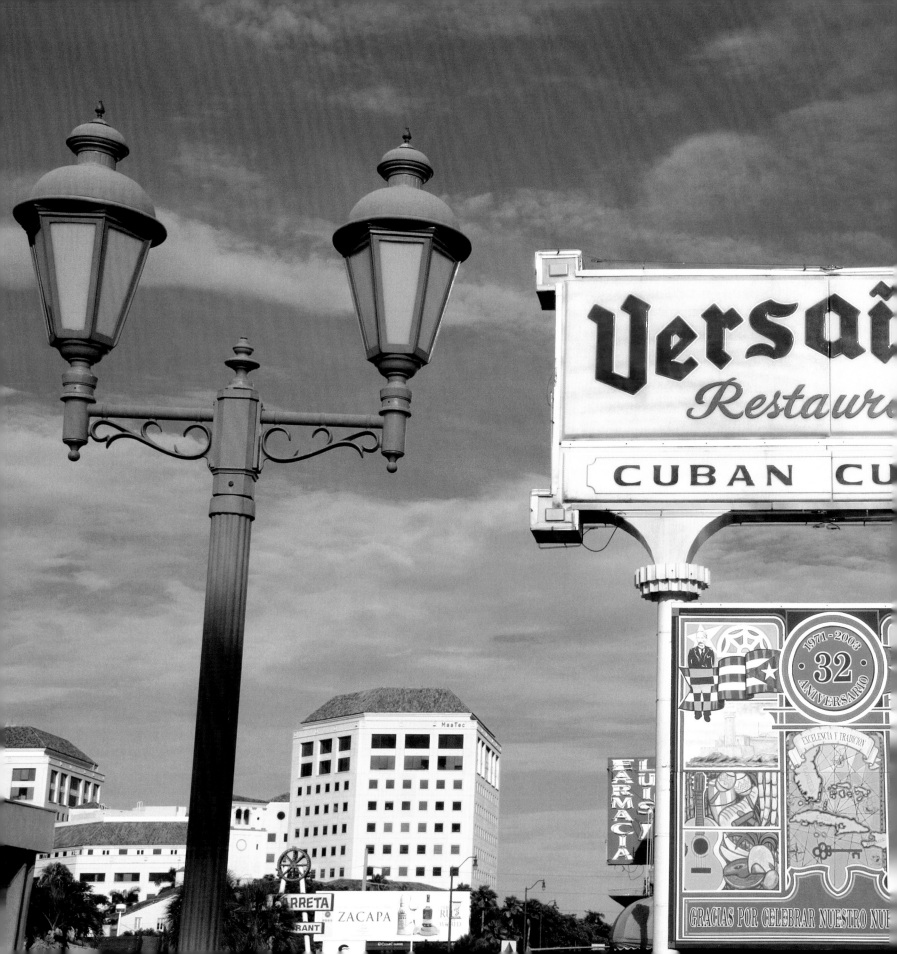

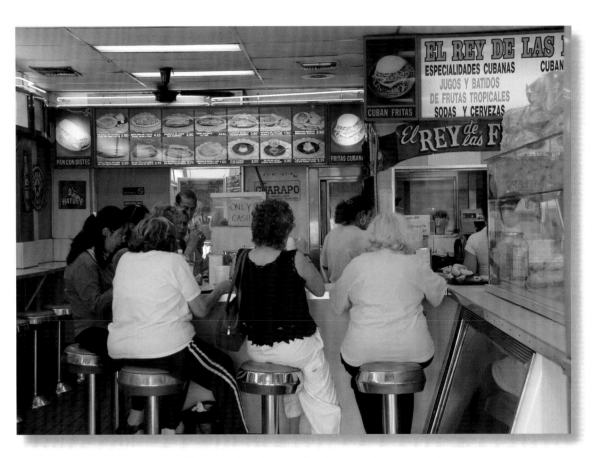

The smell of Cuban coffee wafts through the air from Little Havana's many *corditados*—small cafés serving traditional food and drink.

The Versailles Restaurant offers an extensive menu of traditional Cuban fare. Popular with locals and tourists alike, this kitschy diner buzzes with activity.

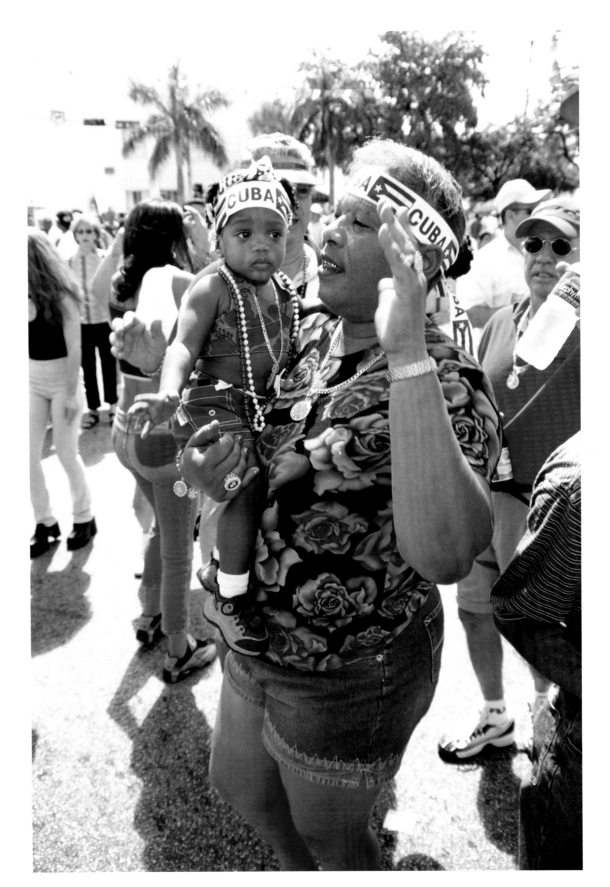

Every March, Little Havana hosts a festival on Calle Ocho that is the biggest street party in the country—more than a million people come from around the world. The streets are packed with revelers enjoying delicious Cuban food and pulsating party music.

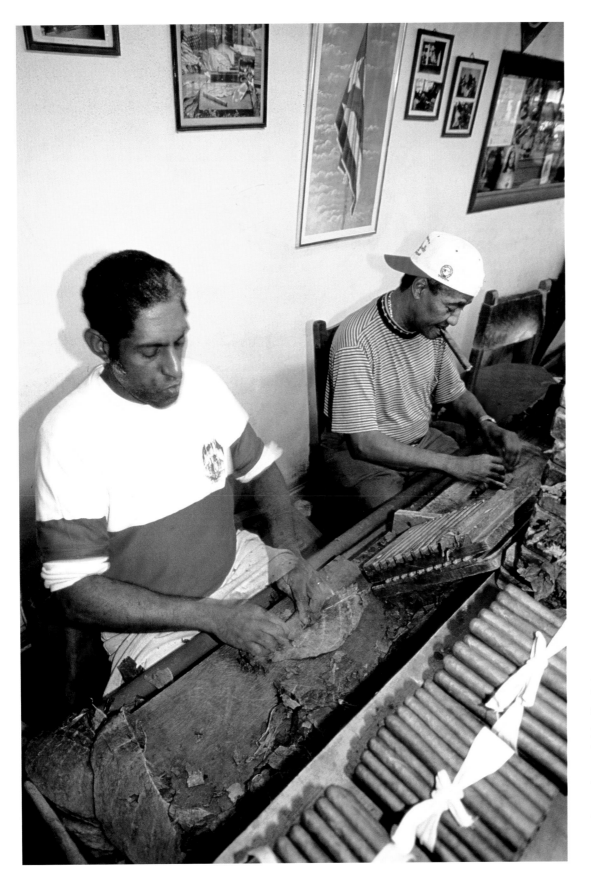

Hand-rolled cigars are a popular item in Little Havana. Here, Cuban immigrants roll La Gloria Cubana cigars, a well-known brand.

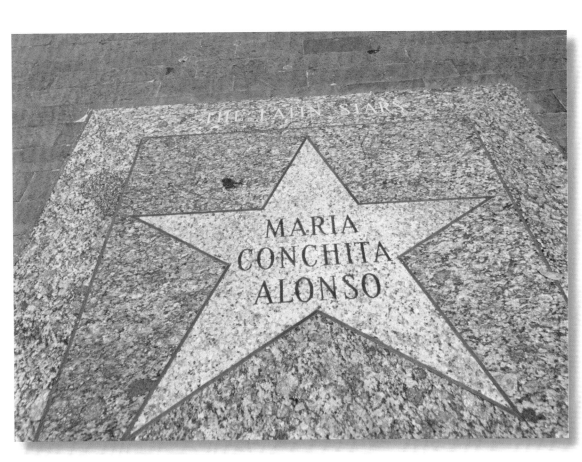

Although this Walk of Fame looks similar to Hollywood's, it's actually the Paseo de las Estrellas—a sidewalk honoring Latin American actors, writers, artists, and musicians.

Miami prides itself on its street-level art. This colorful city is filled with public paintings, sculptures, and installations.

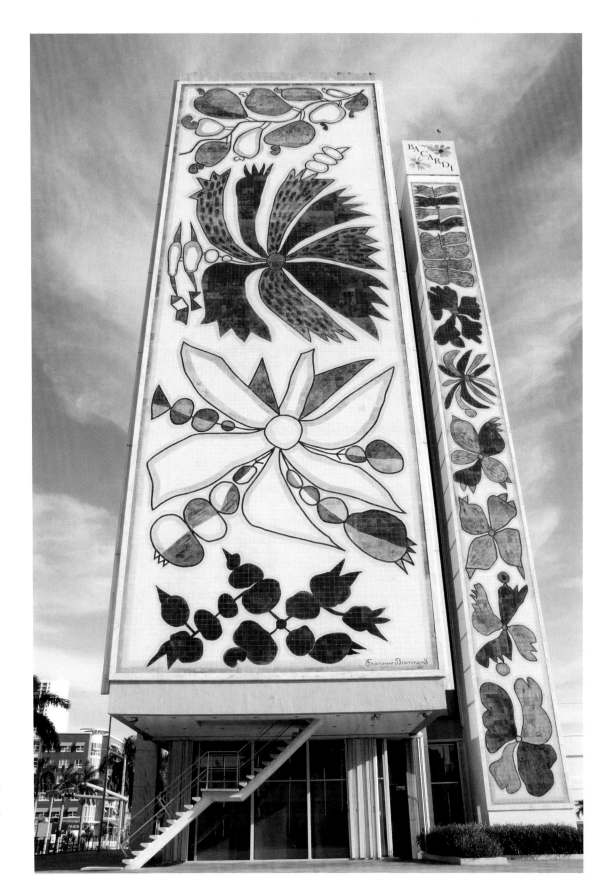

Blue-and-white Spanish tilework decorates the tower of the Bacardi Rum headquarters. The building also houses the Bacardi Museum and an art gallery.

Just north of downtown is the Miami Design District, an 18-block community of fashion and interior designers and artists. The area features galleries, showrooms, and public art such as the Living Room Building.

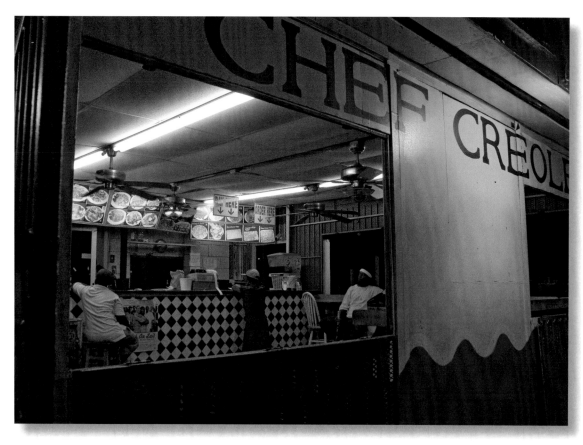

The rhythmic sounds of compass music and the spicy, succulent smells of Creole cooking are just some of the highlights of Miami's Little Haiti district. This bustling community is home to over 30,000 people.

Comprised of more than 80 acres, the Fairchild Tropical Gardens is home to 4,000 colorful species of plants, including orchids, cycads, ferns, flowering trees, and vines.

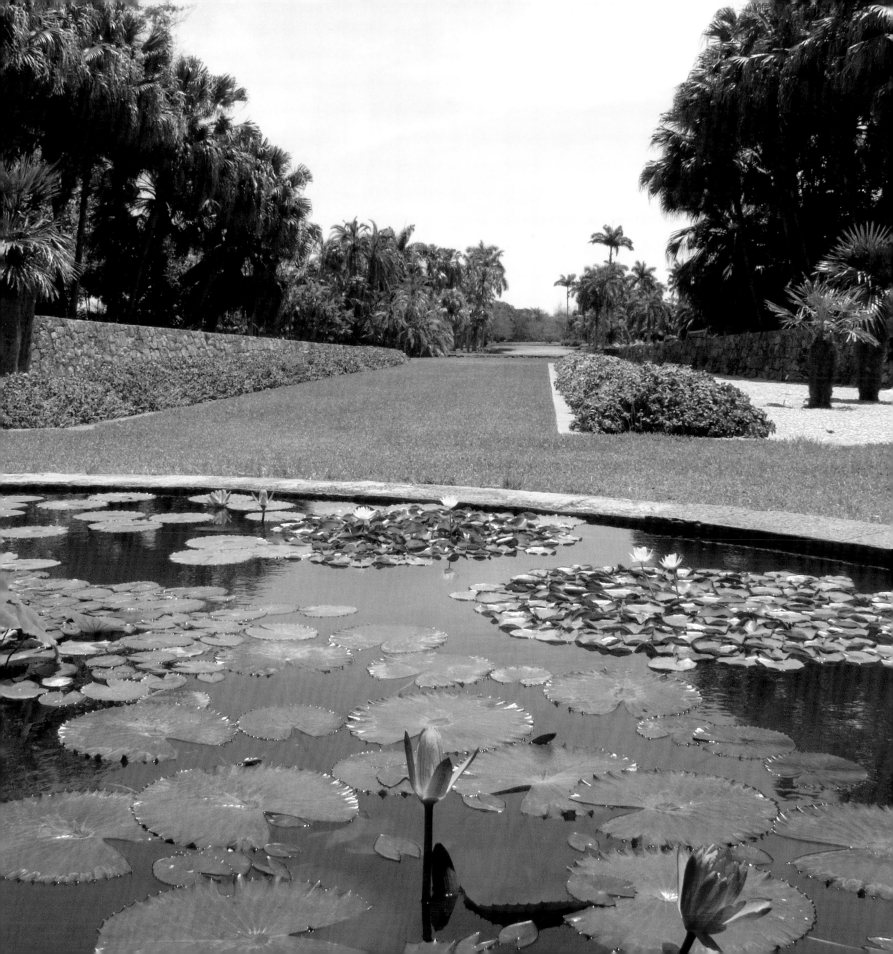

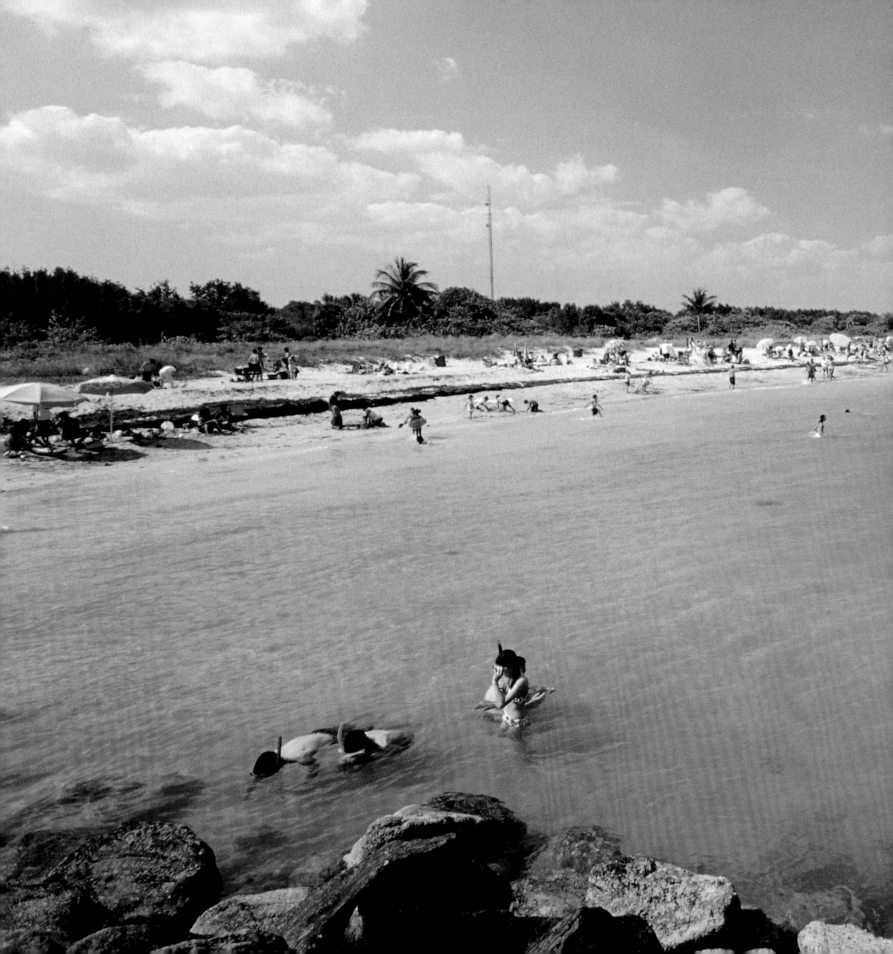

Located where the southern tip of Key Biscayne meets with Bill Baggs Cape Florida State Park is Miami's oldest building—the Cape Florida Lighthouse, built in 1825. Visitors can climb the lighthouse's 109 steps to the observation room to soak up the stunning beach vistas below.

PREVIOUS PAGE
Accessible by the scenic Rickenbacker Causeway, Key Biscayne offers miles of golden sand beaches, tropical foliage, and turquoise waters. Visitors can enjoy tennis and golf at Crandon Park, or hit the ocean for swimming, snorkeling, and kayaking.

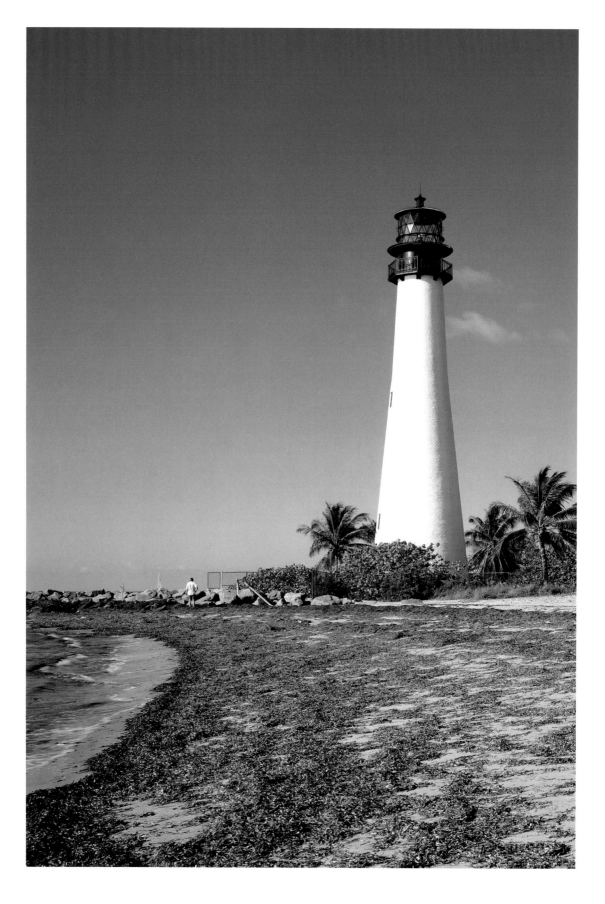

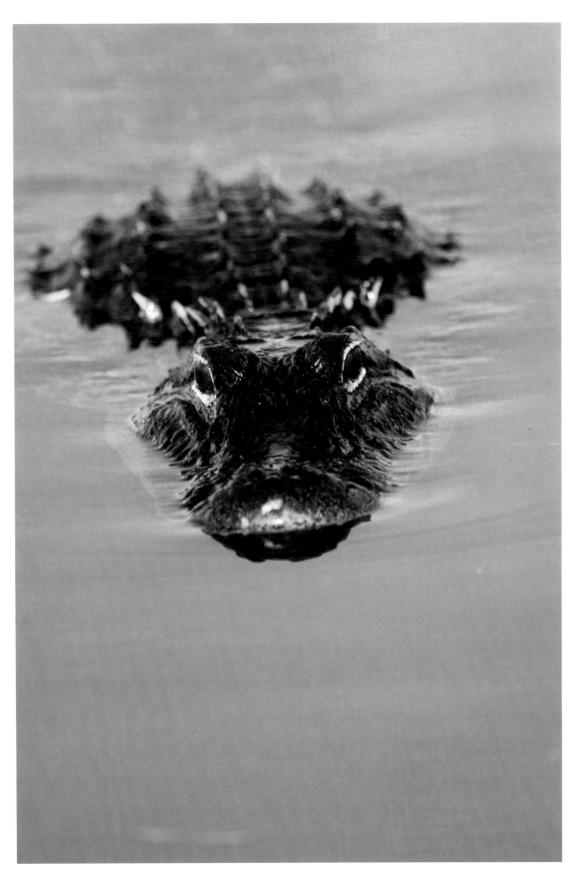

Southern Florida is the only place in the world where alligators and crocodiles co-exist in the same habitat. It's possible to determine which creature is which by the shape of its snout.

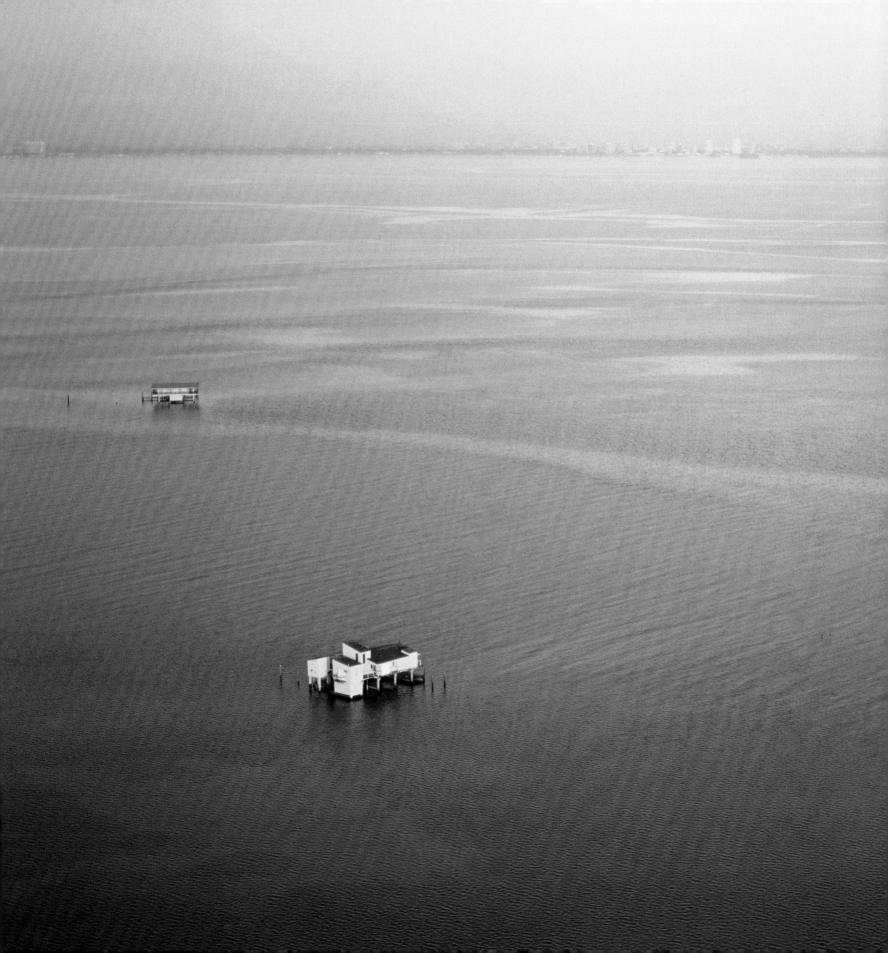

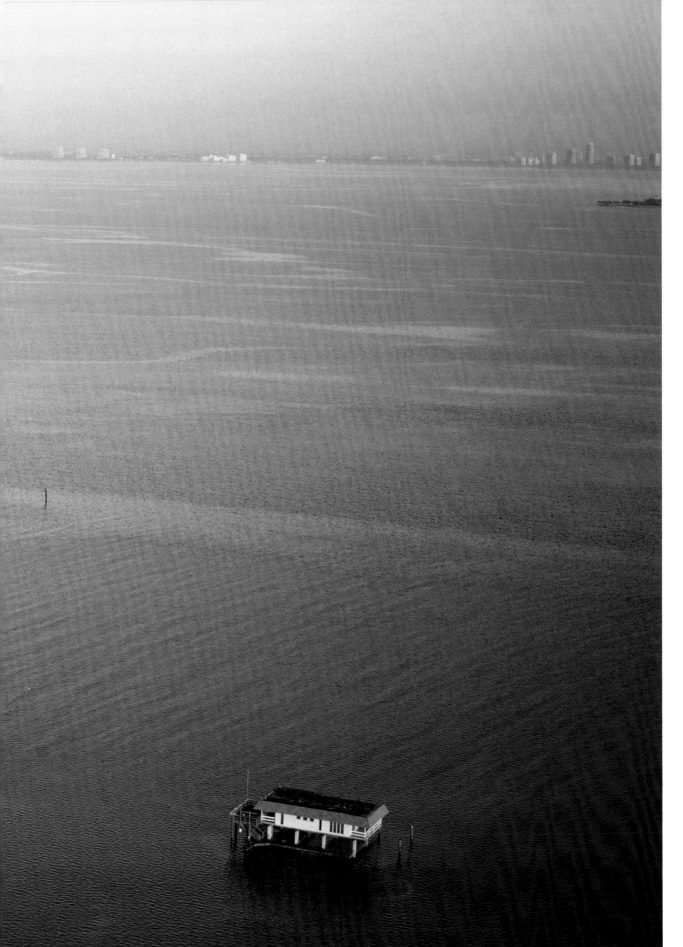

The remnants of a community of stilt houses can be found in Biscayne Bay. These precarious structures—now part of Biscayne National Park—will remain only until the next hurricane destroys them.

OVERLEAF
Located south of Miami, Everglades National Park is the third-largest national park in the continental United States.

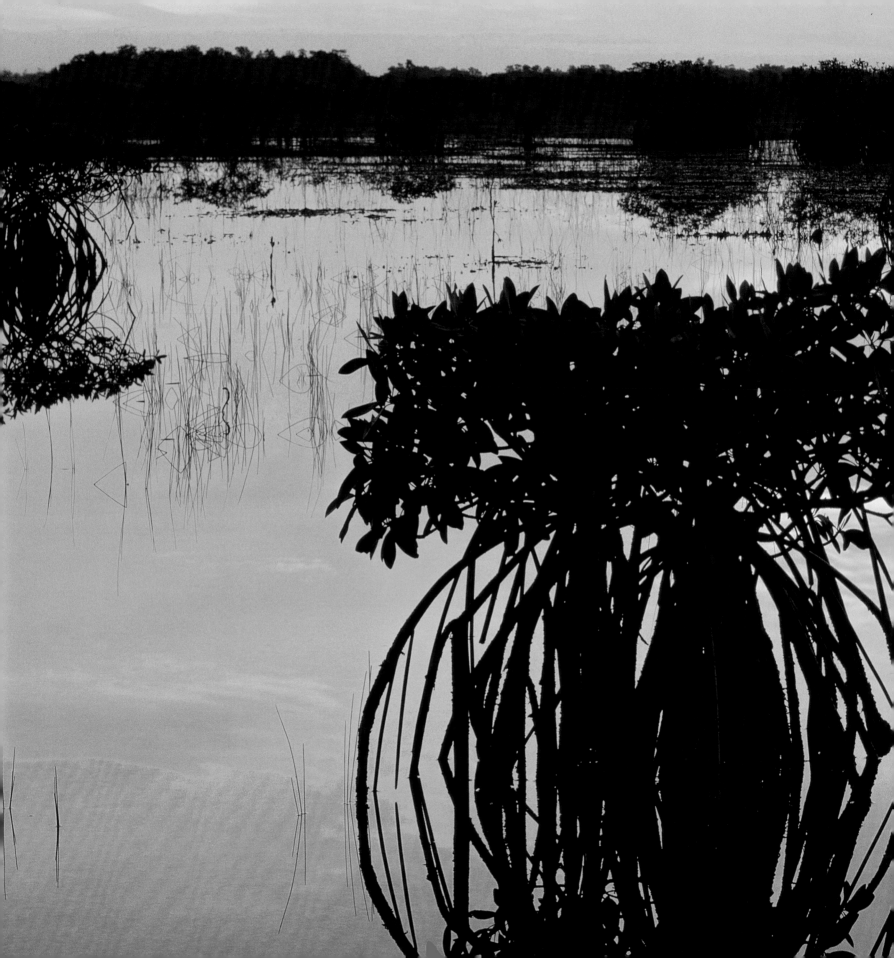

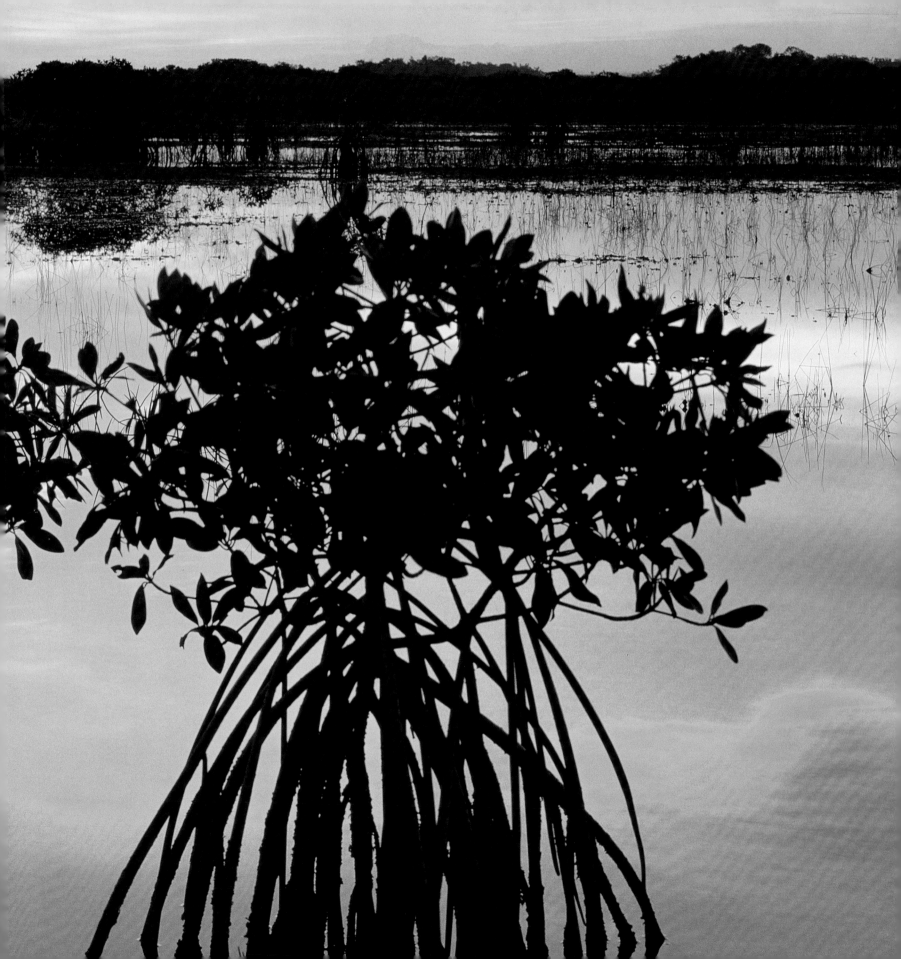

Photo Credits